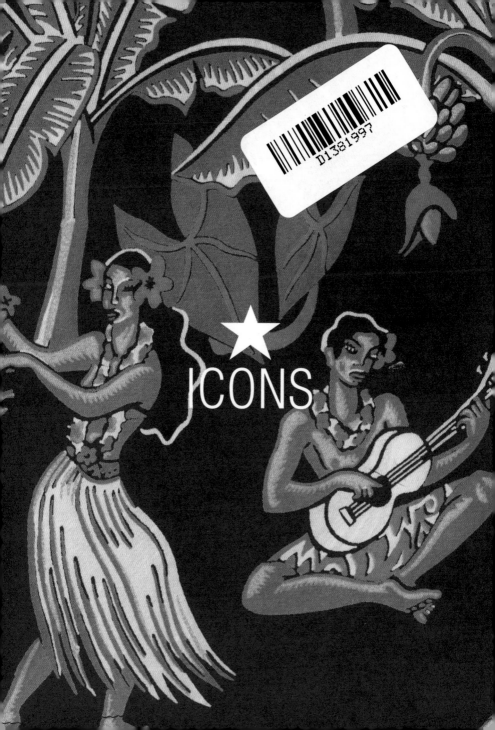

★
ICONS

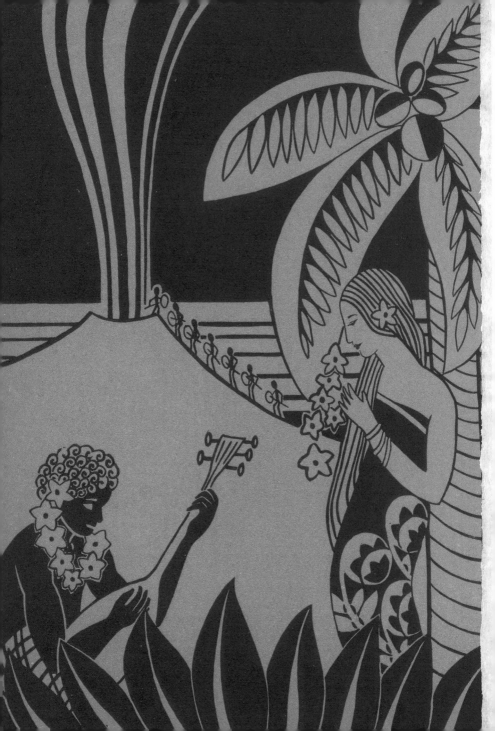

VINTAGE HAWAIIAN GRAPHICS

Ed. Jim Heimann

TASCHEN

KÖLN LONDON LOS ANGELES MADRID PARIS TOKYO

Acknowledgements

Aloha and much thanks go out to all who contributed to the gathering of the hula images found herein. Among them are Tommy Steele, Brad Benedict, Laura Smith, Ralph Bowman, Michael Doret, Patrick Jenkins, Bob Chatt, Dan De Palma, Jeff and Patty Carr, Gary Fredericks, Gary Baseman, John Jacob-Schram, and the countless other vendors at flea markets and paper shows on the mainland and Hawaii.

As usual, a pitcher of Mai Tais goes to Cindy Vance for continuing to patiently and methodically produce the digital files, scans, and design for this series of books. A bottle of rum and a ho ho ho to Nina Wiener for her eagle eye in expertly editing the text and monitoring every aspect of this project. And finally a Sailor Jerry pat on the back to Rob Clayton for the use of his arm.

All images are from the Jim Heimann collection unless otherwise noted. Any omissions for copy or credit are unintentional and appropriate credit will be given in future editions if such copyright holders contact the publisher.

© 2003 TASCHEN GmbH
Hohenzollernring 53, D–50672 Köln
www.taschen.com

Editor: Jim Heimann, Los Angeles
Layout: Cindy Vance, Los Angeles
Cover design: Jim Heimann and
Cindy Vance
Digital scans: Artworks, Pasadena
Production: Tina Ciborowius, Cologne
Project management: Sonja Altmeppen, Cologne
English-language editor: Nina Wiener, Los Angeles
German translation: Harald Hellmann,
Cologne
French translation: Patrick Javault,
Strasbourg

Printed in Italy
ISBN 3–8228–2621–9

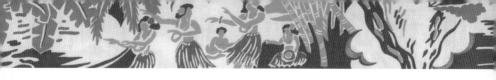

Hula-la
by Jim Heimann

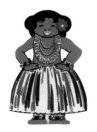

The image of the hula girl, exotic and romantic, has epitomized the somewhat intangible lure of the tropical Pacific for over two centuries. Originating in French Polynesia, the hula dance was later refined in Hawai'i by settlers from the Marquesas and Tahiti, who arrived by outrigger canoe centuries before more far-flung explorers landed. Traditionally aligned with religious practices, the hula relayed legends and history through "oli" (chants) and "mele" (songs accompanied by music and dance), both of which were performed by men and women. The Western world first caught a glimpse of this native dance when English explorer Captain James Cook's ship docked in Hawai'i in 1778. Shortly after their arrival on the island of Kaua'i, his crew was treated to a performance. They fell instantly for the sight and returned to Europe with illustrations of the sensual dance and the bronzed dancers. With the 1820 arrival of Protestant American missionaries and the subsequent conversion of Queen Ka'ahumanu, however, the indigenous culture nearly perished. The hula, perceived by missionaries as a crude and heathen practice, was banned, along with exposed breasts and the islanders' abbreviated clothing.

The dance however, continued to be performed in secret. The hula tradition was handed down through clandestine channels until 1874 when King David Kalakaua, known as the "Merrie Monarch", revived many aspects of traditional Hawaiian culture, including the hula. The dance enjoyed a popular resurgence and was once again performed in public as a "living tradition". Around this time the ukulele — an instrument borrowed from Portuguese immigrants — and the steel guitar were introduced to the musical mix, along with the ti leaf skirt as a dance costume.

In art, printed matter and even tattoos of this period, it was common to confuse the imagery of South Sea island women with that of female Hawaiian hula dancers. Sailors' accounts, as well as those of various writers and artists, described the dances of Polynesia as a series of sexually charged movements performed by topless dancers, which presumed relaxed sexual mores on the part of the native population. Thus, accounts of Hawaiian hula girls often blended with those from other South Pacific archipelagos and a muddled stereotype of the hula girl emerged.

At the turn of the twentieth century, the image of the hula girl became a commodity for Hawai'i to exploit in attracting tourists arriving by steamer ship. Increased travel to the

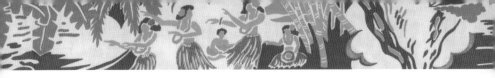

islands eventually led to tourism surpassing agriculture as the region's primary source of income. The Hawai'i Promotion Committee was established in 1903 to accommodate this economic shift and aggressively promote the islands. Although both men and women danced the hula, the feminine form was singled out for her attractiveness and implicit sexuality. Alongside depictions of surfers and the islands' natural beauty, this imagery was effectively relayed in travel brochures, souvenir postcards and an endless variety of promotional material. Troupes of hula dancers were exported to the mainland as ambassadors of the Hawaiian aloha. It was only a matter of time before the mainland appropriated the envoys' act and the lineup at many a circus sideshow included a hula dancer (though not always Hawaiian) as an exotic tease.

By the 1920s, the hula girl had become so embedded in popular international culture that her origins had begun to fade. The ti leaf skirt was traded in for a grass skirt and ukulele. The more realistic depictions of her became stylized and Anglicized, with starlet looks. She appeared on greeting cards and calendars, on match covers and pin-up prints, aloha shirts and neckties. Along with sugar and pineapples, she had become the preeminent export of Hawai'i.

The introduction of air travel between Hawai'i and the mainland in 1935 and the influx of wealthy tourists arriving by luxury liners such as the Matson Line signaled the next wave of visitors to descend on the islands. The hula girl was there to welcome them. Radio programs emanating from Honolulu exported visions of swaying palms and lovely hula hands though music. Photographs of visiting film celebrities posed with a young hula miss ensured wide coverage in newspapers and magazines. Hollywood included her in all sorts of films — *Bird of Paradise*, *Waikiki Wedding* and *Down to Their Last Yacht*, for example — which further promoted her reputation. As a benchmark of beauty, she was unsurpassed.

With the bombing of Pearl Harbor on 7 December 1941 and the entry of the United States into war with Japan, Hawai'i was flooded with American soldiers and sailors. The islands were a jumping-off point for the Pacific battleground and the military personnel were usually young and naive. Exposed for the first time to a culture and place that was entirely different from their hometowns, the thousands of soldiers passing through were eager to experience all that a tropical paradise could offer. The hula girl, already a familiar figure, was suddenly a tangible presence, albeit a stylized and packaged one. Servicemen readily volunteered to dance and perform on stage with professional hula dancers. They

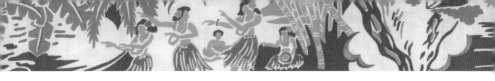

had their pictures taken with models dressed in grass skirts and leis. They eagerly bought photo packets of topless hula girls to plaster on lockers and barracks, an illicit purchase they might never have considered on the mainland. Thousands of servicemen sheepishly returned home, arms and chests emblazoned with hula girl tattoos.

The swell of military personnel who had lingered in Hawai'i during the war years returned with more than just tattooed torsos. Through souvenir hula lamps, pillow covers, playing cards and cigarette lighters, the hula girl was distributed across post-war America. Increased air travel during the 1950s and the hordes of tourists arriving by jet cemented her international reputation as the personification of Hawai'i. Hawaiian statehood in 1959 created yet another wave of interest in all things tropical and a Polynesian craze followed on the mainland with tiki-themed restaurants, backyard luaus, plastic leis and, of course, hula girls in every shape and form.

While the commercial hula girl — wearing an ever-present smile and grass skirt — is still found throughout the world, there is also a resurgence of the dance and a renewed respect for Hawai'i's indigenous culture. Both traditions speak to the idealized maiden of Hawai'i who endures as one of the most alluring icons in popular culture.

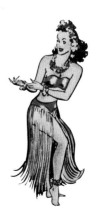

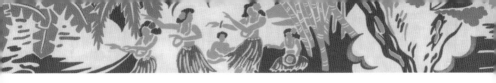

Hula-la

von Jim Heimann

Seit mehr als zwei Jahrhunderten gilt uns das hawaiianische Hula-Girl als Sinnbild für den geheimnisvollen Zauber der Südsee. Der Tanz, der die Hula-Mädchen berühmt machte, hat seinen Ursprung in Französisch-Polynesien. Später brachten Siedler ihn von den Marquesas und von Tahiti nach Hawaii, das sie mit ihren Ausleger-booten schon Jahrhunderte vor den ersten Seefahrern aus Europa erreichten. Von Männern und von Frauen getanzt, tradierte der Hula als fester Bestandteil religiöser Zeremonien durch *oli* (Gesänge) und *mele* (von Instrumenten und Tanz begleitete Lieder) die Mythen und das historische Wissen der Insulaner.

Captain James Cook und seine Crew, die 1778 vor der Hawaii-Insel Kauai Anker warfen, waren die ersten Europäer, die diesen zeremoniellen Tanz kennenlernten. Beeindruckt brachten die Seefahrer farbenfrohe Schilderungen des sinnlichen Tanzes und der bronzehäutigen Tänzerinnen und Tänzer mit zurück in die Heimat. Mit der Ankunft protestantischer Missionare aus Amerika in Jahr 1820 und der anschließenden Bekehrung von Königin Kaahumanu zum christlichen Glauben setzte eine Entwicklung ein, die beinahe zum Niedergang der indigenen Kultur führte. Der Hula, die entblößten Brüste und die freizügige Kleidung der Insulanerinnen waren aus Sicht der Missionare schamlos und heidnisch. Und so sprachen sie kurzerhand ein Verbot aus.

Doch ungeachtet der Repressionen lebte der Tanz im Verborgenen weiter. Mit König David Kalakaua, dem »Fröhlichen Monarchen«, setzte ab 1874 eine Rückbesinnung auf die traditionelle hawaiianische Kultur ein, die aber durchaus auch offen für Neues war: die Ukulele – ein Mitbringsel portugiesischer Immigranten – und die Steel Guitar wurden etwa in dieser Zeit in die facettenreiche hawaiianische Musik integriert und das Ti-Leaf-Röck-chen wurde zum klassischem Kostüm der Tänzerinnen und Tänzer.

In der Kunst, den Printmedien und sogar in Tätowierungen aus dieser Zeit stand die hawaiianische Hula-Tänzerin für die Südsee-Insulanerin schlechthin. Matrosen, Reise-schriftsteller und Künstler sahen in den Tänzen Polynesiens vornehmlich sexuell provo-zierende Bewegungen barbusiger Tänzerinnen. Wer mochte da nicht glauben, dass die sexuellen Sitten der indigenen Bevölkerung mehr als locker waren? Eindrücke von Hula-Tänzen, Erlebnisse auf anderen Südsee-Archipelen und die eigenen Wunschvorstellungen vermengten sich zu einem wirren Klischeebild.

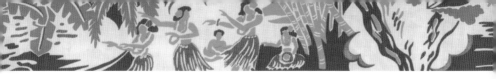

An der Schwelle zum 20. Jahrhundert wurde das Hula-Mädchen *das* Markenzeichen Hawaiis. Der Tourismus gewann in dieser Zeit zunehmend an Bedeutung und löste schon bald die Landwirtschaft als Haupteinnahmequelle Hawaiis ab. 1903 wurde das Hawai'i Promotion Committee eingerichtet, um dieser ökonomischen Gewichtsverlagerung Rechnung zu tragen und die Inseln aggressiv zu vermarkten. Neben Bildern von Surfern und den Naturschönheiten der Inseln zierten Bilder attraktiver Hula-Tänzerinnen bald Reisekataloge, Souvenirpostkarten und zahllose andere Werbeartikel. Ja, man schickte sogar ganze Hula-Tanzgruppen als Botschafter des hawaiianischen Alohas in die Vereinigten Staaten. Die schwangen so erfolgreich die Hüften, dass schon bald keine Schaubude und kein Varieté auf den erotischen Appeal eines Hula-Mädchens verzichten wollte (auch wenn so manches von ihnen Hawaii bloß aus den Illustrierten kannte).

Um 1920 war das Hula-Mädchen eine feste Größe in der internationalen Populärkultur, und ihre eigentliche Bedeutung und Herkunft nur noch wenigen bekannt. Der traditionelle Ti-Leaf-Rock wurde durch Baströckchen ersetzt, man drückte ihr die Ukulele in die Hand und glich ihre Züge westlichen Schönheitsvorstellungen an – das Hula-Girl wurde zum Starlet. Es erschien auf Grußpostkarten und Kalendern, auf Streichholzbriefchen und Pin-Up-Postern, auf Hawaii-Hemden und Krawatten. Neben Zucker und Ananas wurde es zum wichtigsten Exportartikel Hawaiis.

Die Einrichtung einer festen Flugverbindung zwischen Hawaii und den Staaten im Jahr 1935 und Luxusliner von Schiffahrtsgesellschaften wie der Matson Line verstärkten den touristischen Zustrom auf die Inseln. Auf der Rollbahn und am Kai erwartete die vermögenden Touristen bereits das Hula-Girl. Radiostationen in Honolulu taten das ihre, um mit populären Liedern das Klischee von sich wiegenden Palmen und hübschen Hula-Mädchen weiter zu verbreiten. Filmstars ließen sich bei ihren Besuchen auf den Inseln neben jungen Hula-Schönheiten ablichten und garantierten ihnen eine ständige Präsenz in Zeitungen und Magazinen. Natürlich wollte auch Hollywood beim großen Hula-Boom dabei sein und ließ in Filmen wie *Bird of Paradise, Waikiki Wedding, Down to Their Last Yacht* und zahllosen anderen die Baströcke rascheln.

Nach dem japanischen Überfall auf Pearl Harbour am 7. Dezember 1941 und der darauf folgenden Kriegserklärung der USA an Japan wurde Hawaii von amerikanischen Soldaten und Matrosen überflutet. Die Inseln dienten als Sprungbrett für den pazifischen Kriegsschauplatz und die meisten der eintreffenden Soldaten waren jung, naiv und zum

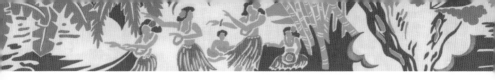

ersten Mal in ihrem Leben einer Kultur ausgesetzt, die so gänzlich anders war als alles was sie kannten. Natürlich wollten sie auskosten, was das Tropenparadies ihnen zu bieten hatte. Das Hula-Girl, aus Kino und Illustrierten eine vertraute Gestalt, war nun plötzlich greifbar nahe, und die GIs kannten kein Halten mehr. Sie schwangen neben professionellen Hula-Tänzerinnen das Tanzbein, sie ließen sich neben den mit Blüten-Leis behängten Modellen im Bastrock fotografieren und erstanden begeistert Fotos barbusiger Hula-Mädchen, um damit ihre Spinde und Unterkünfte vollzukleistern; übrigens ein gesetzwidriger Erwerb, den sie daheim wohl niemals gewagt hätten. Tausende von unbedarften Soldaten trugen bei ihrer Rückkehr in die Staaten Hula-Girl-Tätowierungen auf Armen und Oberkörper.

Das Gros des Militärpersonals, das während der Kriegsjahre auf Hawaii stationiert war, kehrte aber nicht nur mit Tätowierungen in die Heimat zurück. Souvenirs wie Hula-Lampen, Hula-Kissenbezüge, Hula-Spielkarten und Hula-Feuerzeuge brachten das Bild der Inselschönheit noch in die verschlafenste Kleinstadt der Nachkriegs-USA. Als Hawaii 1959 Bundesstaat der USA wurde, löste das eine neue Welle der Begeisterung für alles Polynesische aus, die den Staaten Tiki-Restaurants, Luaus im Hinterhof, Plastikblumenketten und selbstverständlich Hula-Girls in allen erdenklichen Formen bescherte.

Heute, im 21. Jahrhundert, ist auch das Interesse am traditionellen Hula-Tanz und dem authentischen Gesicht der indigenen Kultur Hawaiis wieder aufgelebt. Doch das kommerzielle Hula-Girl mit seinem Bastrock und dem immer währenden Lächeln ist als eine der verführerischsten Ikonen der Popkultur auf der ganzen Welt heimisch geworden.

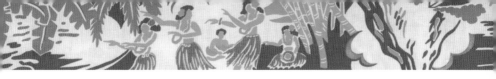

Hula-la
par Jim Heimann

La jeune danseuse de hula, exotique et romantique, a pendant plus de deux cents ans incarné le charme impalpable du Pacifique tropical. Originaire de la Polynésie française, le hula fut affiné à Hawaii par des migrants des Marquises et de Tahiti, arrivés sur leurs pirogues à balancier des siècles avant les premiers explorateurs. Traditionnellement lié à des pratiques religieuses, le hula transmettait les légendes et l'histoire à travers les «oli» (chants) et les «mele» (chansons accompagnées de musique et de danse), interprétés aussi bien par les hommes que par les femmes.

Le monde occidental eut pour la première fois un aperçu de cette danse indigène, lorsque le bateau de l'explorateur anglais James Cook accosta à Hawaii en 1778. Peu de temps après leur arrivée sur l'île de Kauai, les hommes de son équipage eurent droit à une représentation. Ils furent immédiatement séduits, et ils ramenèrent en Europe des illustrations de ces danses sensuelles et des danseurs à la peau cuivrée. Pourtant, avec l'arrivée en 1820 des pasteurs américains et la conversion au christianisme de la reine Kaahumanu, la culture indigène disparut presque totalement. Le hula, considéré par les missionnaires comme une danse primitive et païenne, fut proscrit en même temps que les seins nus et le vêtement rudimentaire des insulaires.

La danse continua cependant d'être pratiquée en secret. La tradition se transmit clandestinement jusqu'à ce qu'en 1874, le roi David Kalakaua, surnommé le «joyeux monarque», fît renaître de nombreux éléments de la culture hawaïenne traditionnelle, et notamment le hula. La danse connut un regain populaire et fut à nouveau pratiquée en public en tant que «tradition vivante». C'est à la même époque que l'ukélélé – un instrument emprunté aux immigrants portugais – et la guitare hawaïenne vinrent enrichir la partie musicale, en même temps que la jupe en feuilles de ti fut adoptée comme costume de danse.

Dans l'art, les livres et mêmes les tatouages de cette époque, il était courant de faire un amalgame entre les femmes des mers du Sud et les Hawaïennes danseuses de hula. Les récits de marins, ainsi que ceux de nombreux écrivains et artistes, décrivaient les danses de Polynésie comme une suite de mouvements chargés d'érotisme, accomplis par des danseuses aux seins nus, ce qui sous-entendait que les mœurs de cette population étaient moins rigides. Comme les jeunes Hawaïennes étaient souvent confondues dans les récits avec les femmes des autres archipels du Pacifique sud, il se créa peu à peu un stéréotype confus de la jeune danseuse de hula.

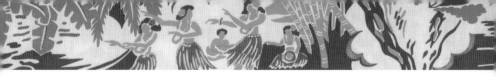

Au tournant du 20^e siècle, l'image de la jeune danseuse de hula devint une marchandise exploitée par Hawaii pour attirer les touristes débarquant des bateaux à vapeur. Le développement des voyages vers les îles transforma l'économie du pays : le tourisme devint la première source de revenus de la région, devançant l'agriculture. Le Comité de Promotion de Hawaii fut fondé en 1903 afin de mieux répondre à ce bouleversement économique et de faire connaître les îles dans le monde entier. Bien que le hula fût dansé aussi bien par les hommes que par les femmes, c'est la forme féminine qui fut mise en avant en raison de son pouvoir séducteur et de sa sexualité implicite. Cette image était en effet diffusée dans les brochures de voyages, les cartes postales et une quantité d'objets publicitaires, à côté de portraits de surfers et de vues des îles. Des troupes de danseuses de hula furent envoyées sur le continent en tant qu'ambassadrices de l'aloha hawaïen. Le continent ne fut pas long à s'approprier les danses de ces messagères, et dans de nombreux spectacles de foire figurait une danseuse de hula (pas toujours hawaïenne) pour son piquant exotique.

Dans les années 20, la danseuse de hula s'était à ce point fondue dans la culture populaire que le souvenir de ses origines commençait à s'estomper. Elle troqua sa jupe en feuille de ti pour une jupe en raphia et se présenta munie d'un ukélélé. Les plus réalistes de ses représentations se stylisèrent et s'anglicisèrent, lui donnant des airs de starlette. Elle apparaissait sur les cartes de vœux et les calendriers, sur les pochettes d'allumettes et parmi les images de pin-ups, sur les chemises hawaïennes et les cravates. Elle était devenue un produit d'exportation essentiel, au même titre que le sucre et les ananas.

Avec la création en 1935 d'une ligne aérienne entre Hawaii et le continent, et grâce aussi aux luxueux paquebots de la Matson Line, les îles attirèrent une masse de riches touristes. La jeune fille « hula » était toujours là pour les accueillir. Les programmes de radio diffusés depuis Honolulu exportèrent à travers la musique des visions de palmiers bercés par le vent et d'adorables mains se mouvant au rythme du hula. Les photos de stars de cinéma en visite posant avec une jeune danseuse hawaïenne étaient largement diffusées dans les journaux et dans les magazines. Hollywood la fit figurer dans toutes sortes de films – *Bird of Paradise*, *Waikiki Wedding* et *Down to Their Last Yacht*, par exemple – contribuant à peaufiner son image. Elle constituait le canon de la beauté féminine, et en cela elle était insurpassable.

Après l'attaque sur Pearl Harbor le 7 décembre 1941 et l'entrée en guerre des États-Unis contre le Japon, les soldats et les marins américains affluèrent à Hawaii. Les îles

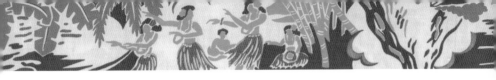

constituaient une base avancée pour la bataille du Pacifique et le personnel militaire était généralement jeune et naïf. Confrontés pour la première fois à une culture et à un lieu totalement différent de leurs villes natales, les milliers de soldats qui y séjournèrent étaient impatients de goûter à tout ce que pouvait offrir un paradis tropical. Figure déjà familière, la jeune danseuse de hula devenait soudain une réalité tangible, bien que stylisée et «empaquetée». Les militaires ne se faisaient pas prier pour danser et jouer sur scène avec des danseuses professionnelles. On les prenait en photo avec des modèles vêtues de leis et de jupes en raphia. Ils achetaient avidement des quantités de photos de jeunes danseuses aux seins nus pour en tapisser leurs placards ou les murs de leurs chambrées – un achat illicite auquel ils n'auraient même pas songé sur le continent. Des milliers de soldats revinrent sagement chez eux, les bras et la poitrine ornés de tatouages de filles «hula».

Quant à la hiérarchie militaire stationnée à Hawaii durant les années de guerre, elle ne revint pas avec de simples tatouages. Grâce aux lampes «hula», aux taies d'oreiller, aux cartes à jouer et aux briquets, l'image de la jeune danseuse hawaïenne se répandit dans toute l'Amérique d'après-guerre. L'augmentation du trafic aérien dans les années 50 et l'afflux de touristes arrivant par jets entiers, contribuèrent à faire d'elle, pour toujours et dans le monde entier, l'incarnation du paradis insulaire tropical. La création de l'État de Hawaii en 1959 entraîna une nouvelle vague d'intérêt pour l'exotisme tropical sous toutes ses formes et une folie polynésienne s'empara du continent. On vit apparaître des restaurants tiki, des jardins luau, des leis en plastique et bien entendu aussi des jeunes danseuses de hula, de toutes les statures et de toutes les apparences.

Certes, l'image commercialisée de la jeune danseuse hawaïenne à l'éternel sourire, vêtue d'une simple jupe de raphia, se rencontre encore partout dans le monde, mais on assiste aussi à une renaissance du hula et à un regain de considération pour la culture indigène hawaïenne. Les deux traditions s'adressent à la jeune fille idéalisée de Hawaii qui reste l'une des plus séduisantes icônes de la culture populaire.

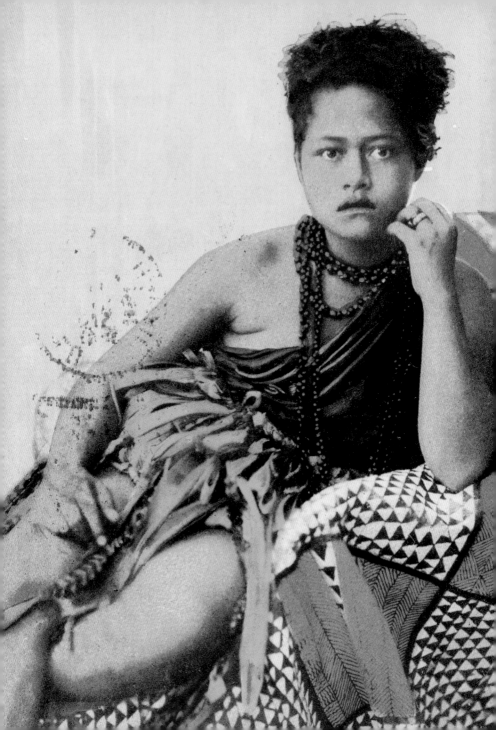

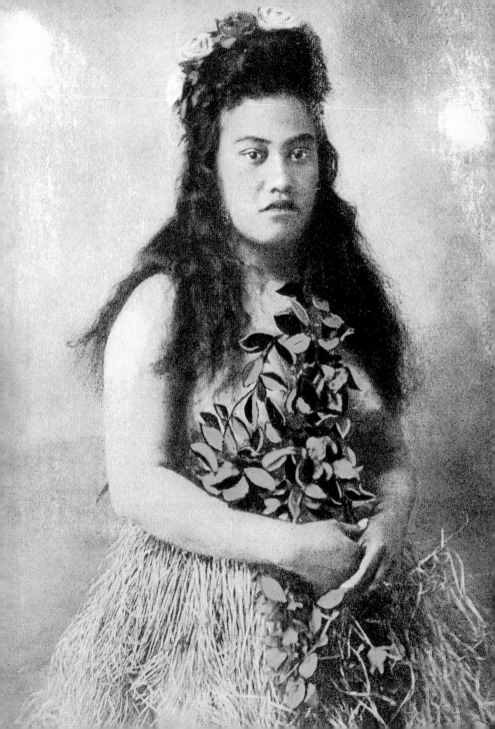

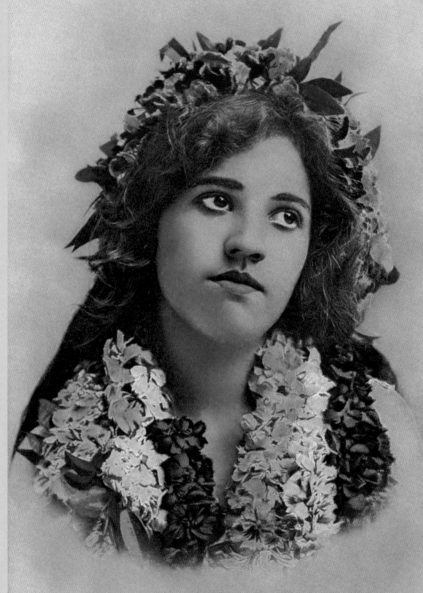

86. Hawaiian Beauty.

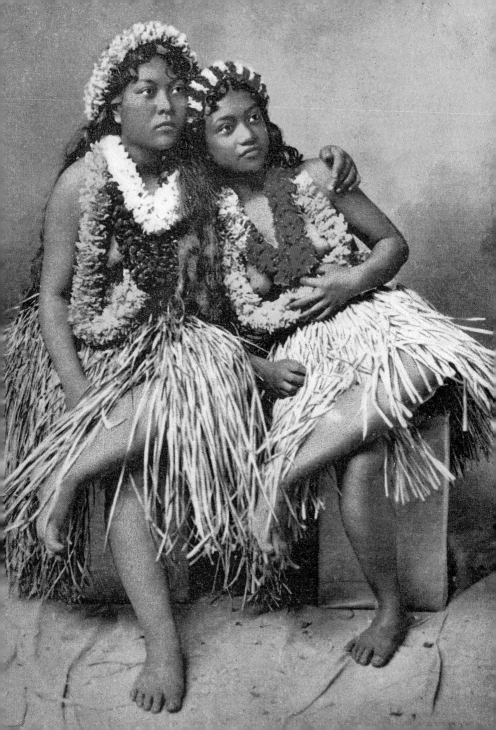

ALOHA FROM HAWAII

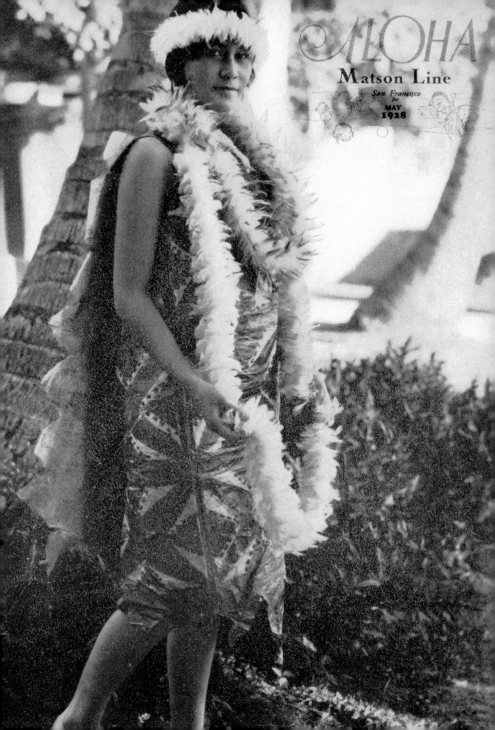

ALOHA

Matson Line

San Francisco
for
MAY
1928

NATIONAL PEPSIN GUM CO.

CHEWING GUM MANUFACTURERS

1130 MISSION STREET

SAN FRANCISCO

January 10, 1920

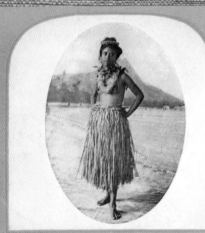

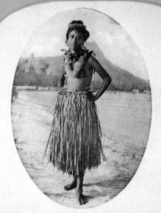

1336. Hula Dancing Girl, a Native of the Hawaiian Islands.

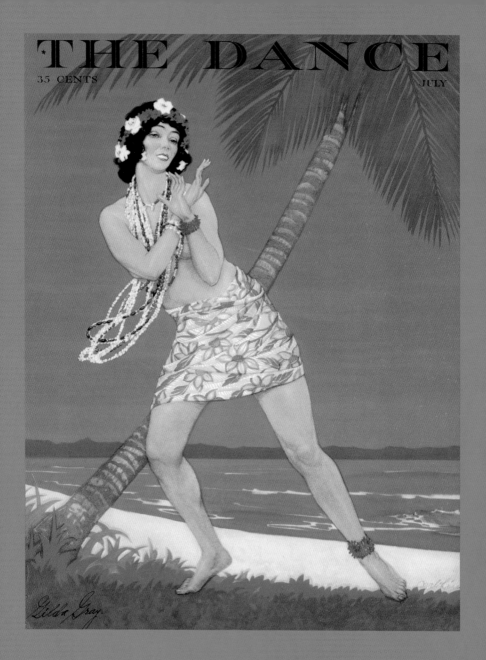

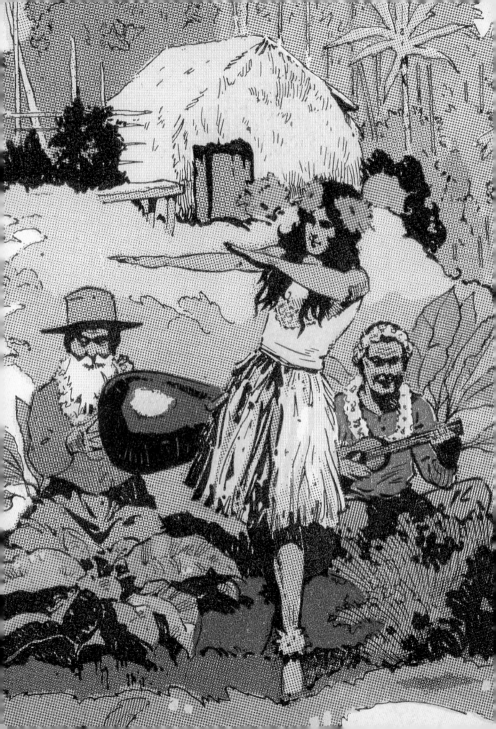

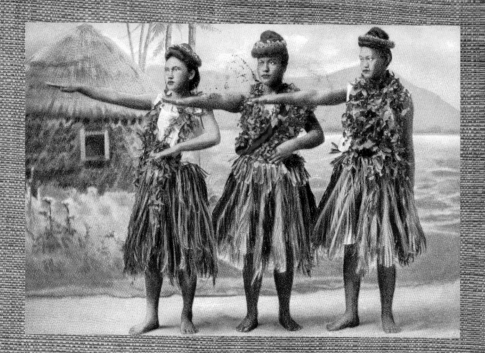

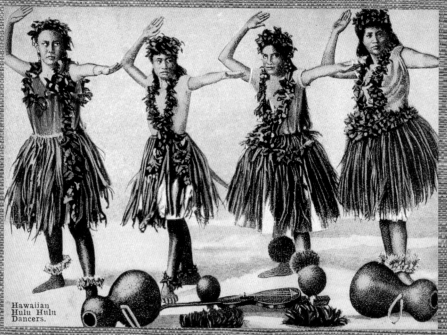

Hawaiian
Hulu Hulu
Dancers.

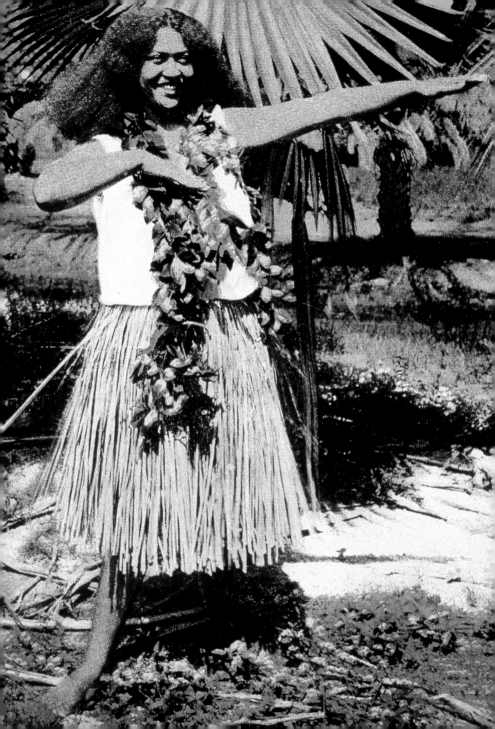

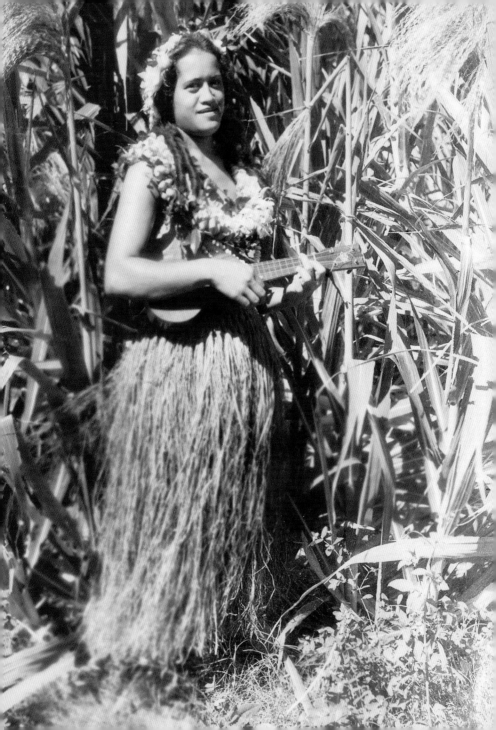

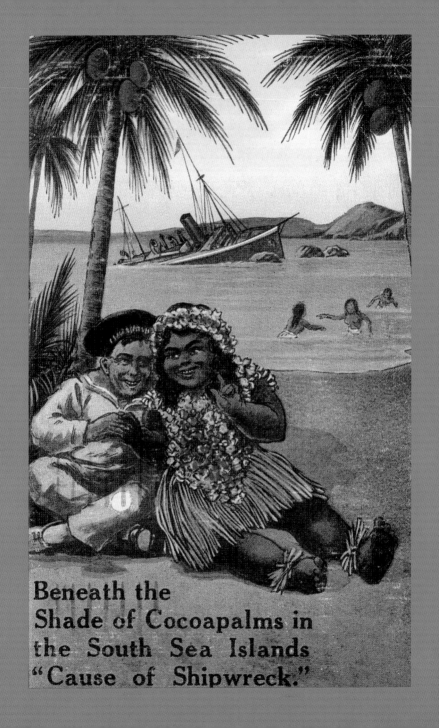

Beneath the
Shade of Cocoapalms in
the South Sea Islands
"Cause of Shipwreck."

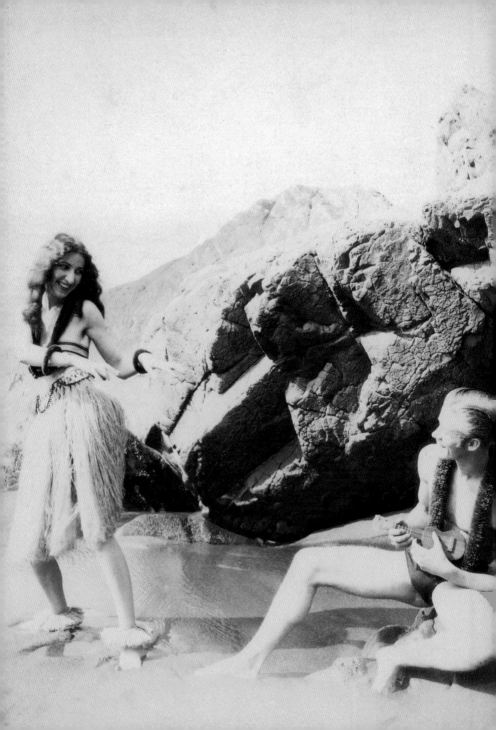

Life

April 10
1931

Price
10 Cents

Travel Number

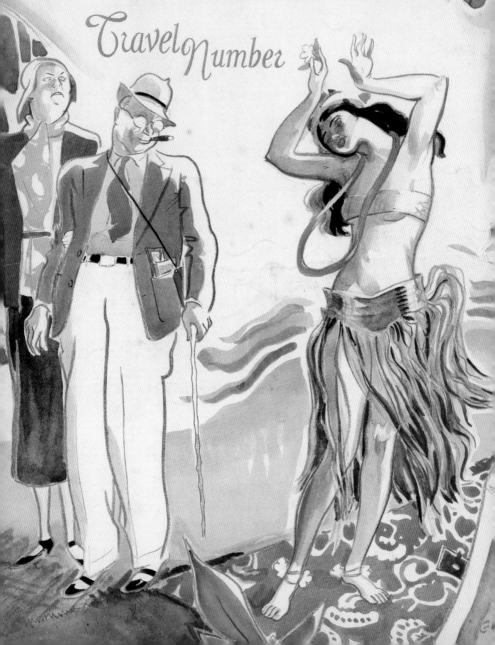

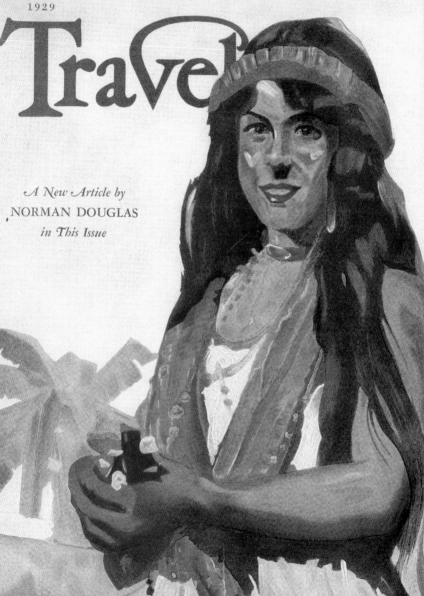

NOVEMBER
1929

Travel

A New Article by
NORMAN DOUGLAS
in This Issue

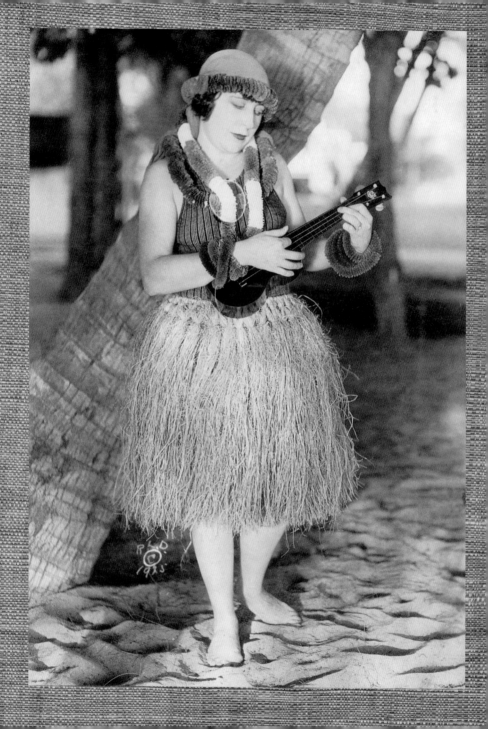

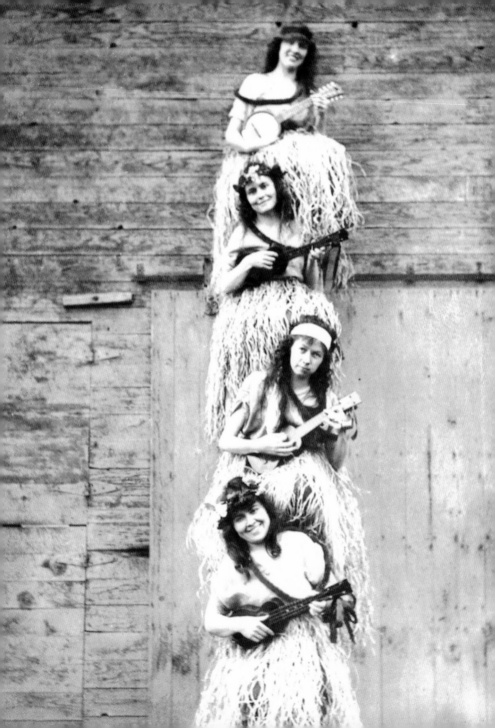

HAWAIIAN GIRL
BRAND

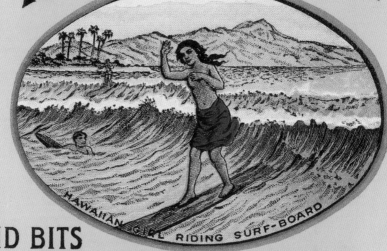

HAWAIIAN GIRL RIDING SURF-BOARD

TID BITS

HAWAIIAN PINEAPPLE

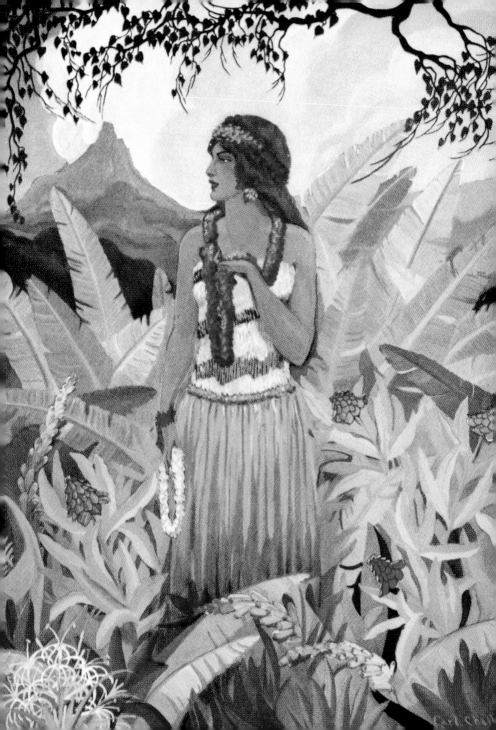

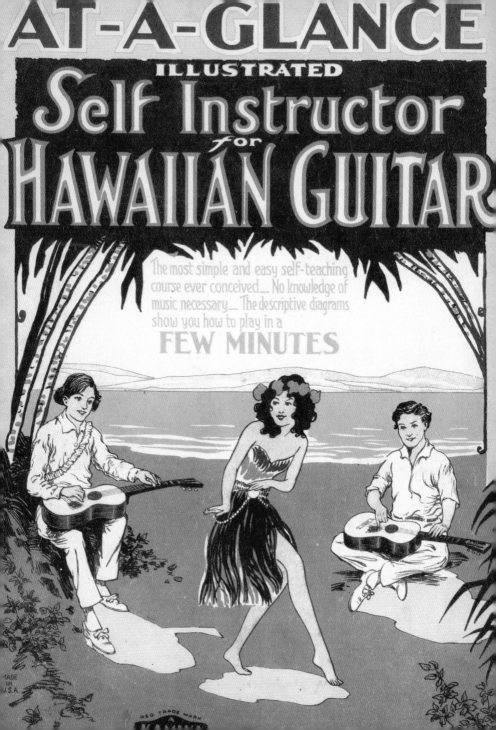

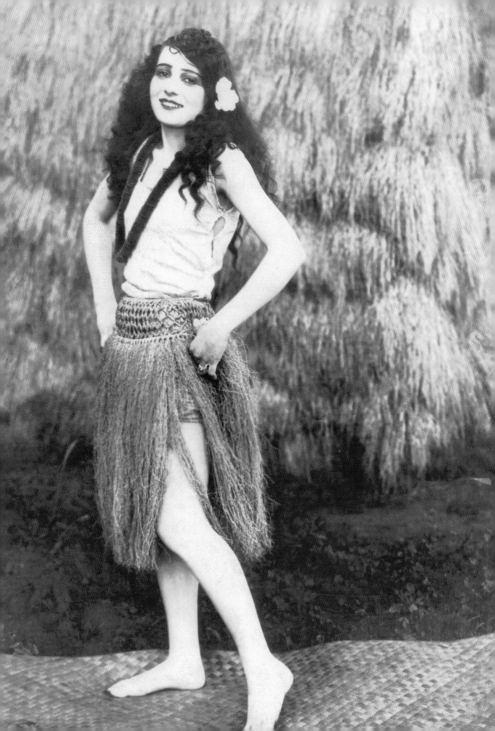

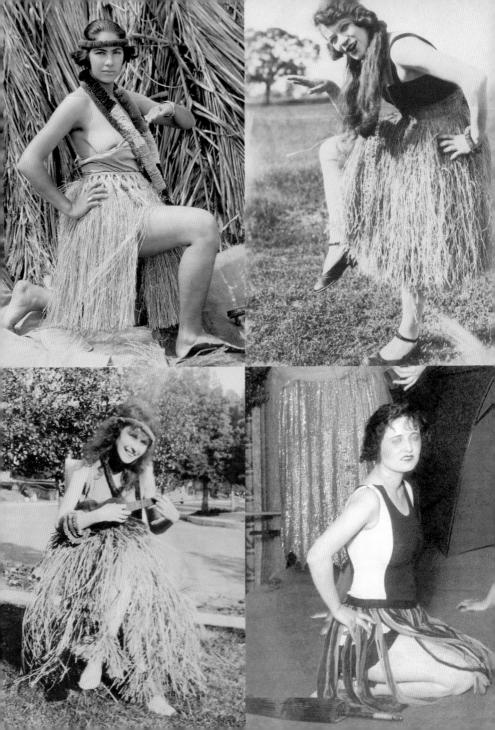

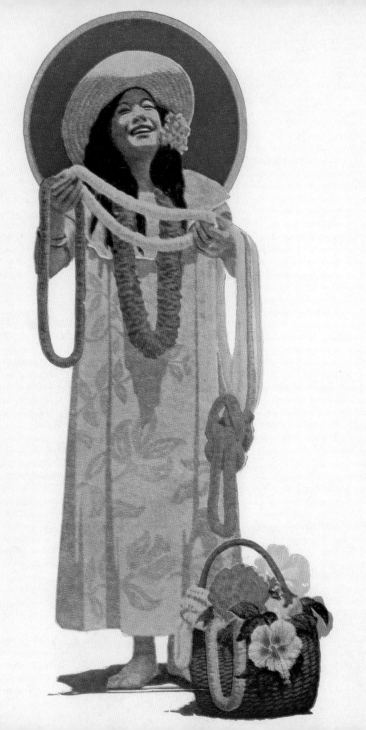

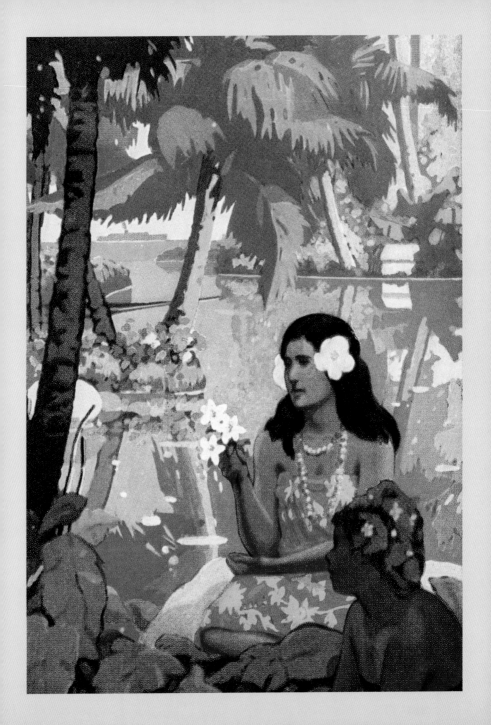

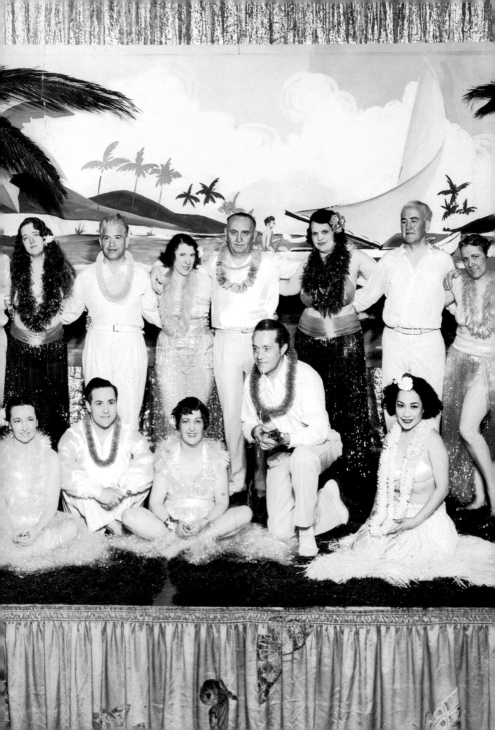

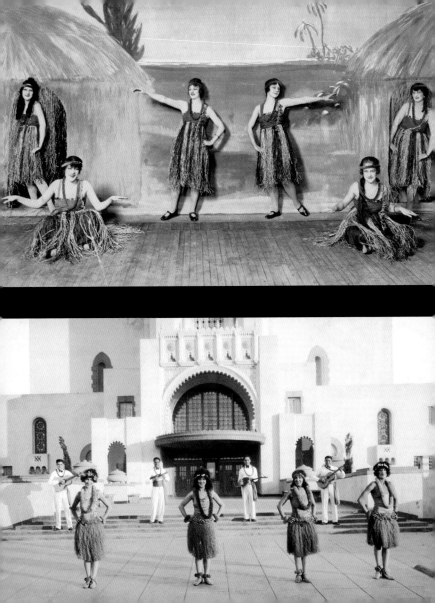

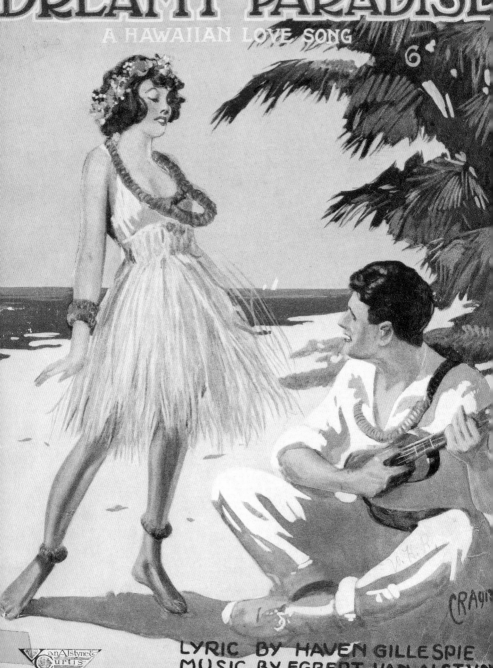

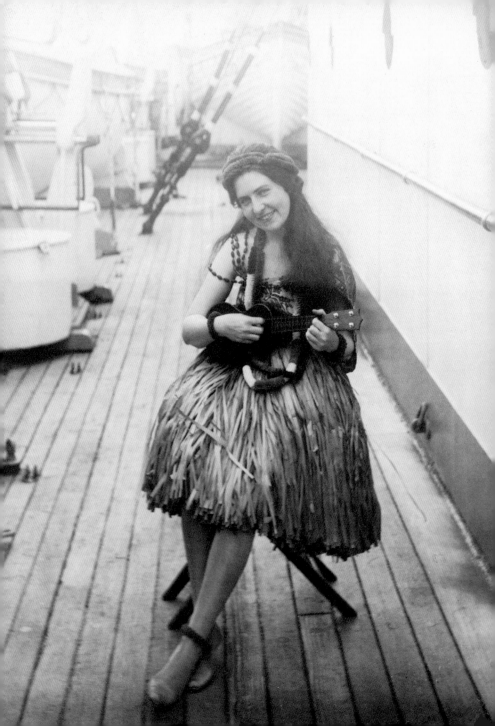

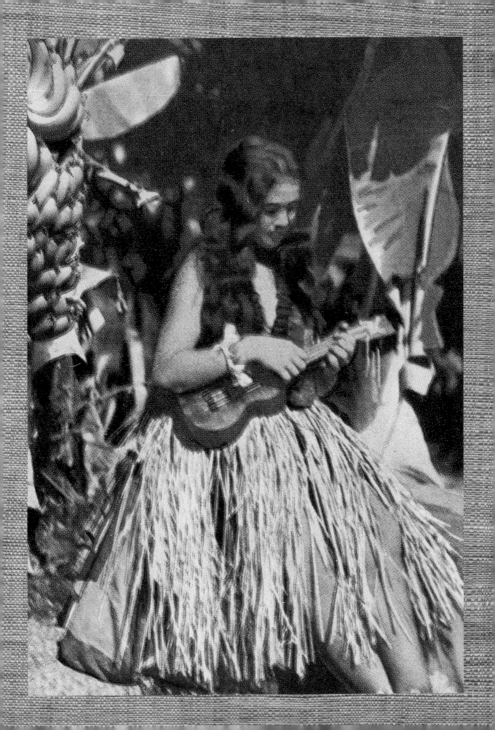

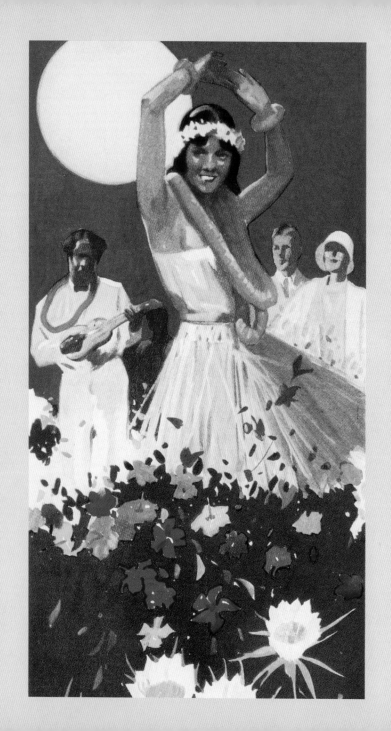

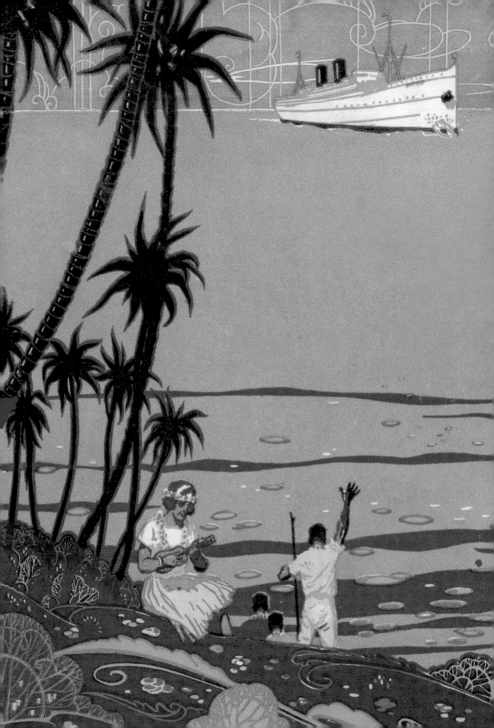

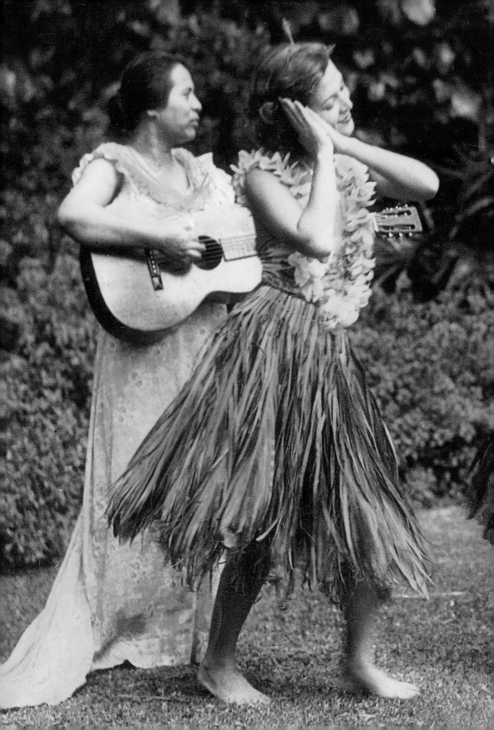

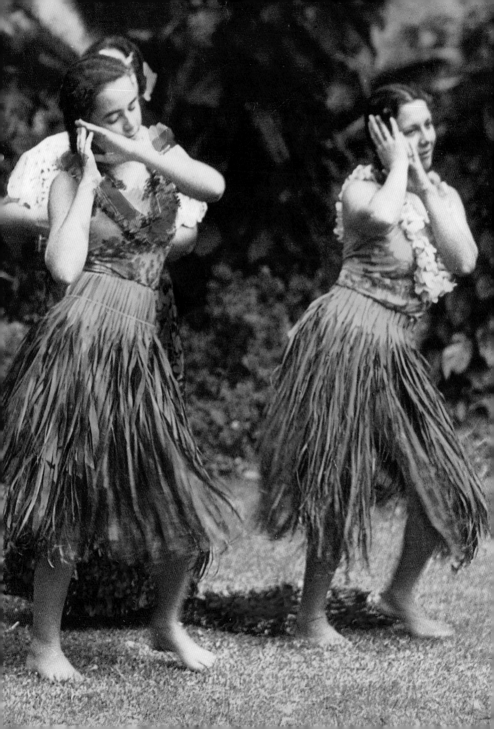

PARADISE

OF THE

PACIFIC

ALOHA

Holiday Number

PRICE
One Dollar

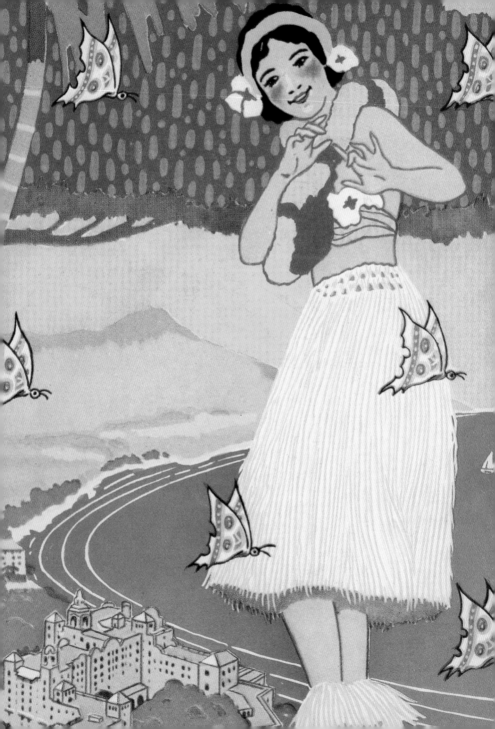

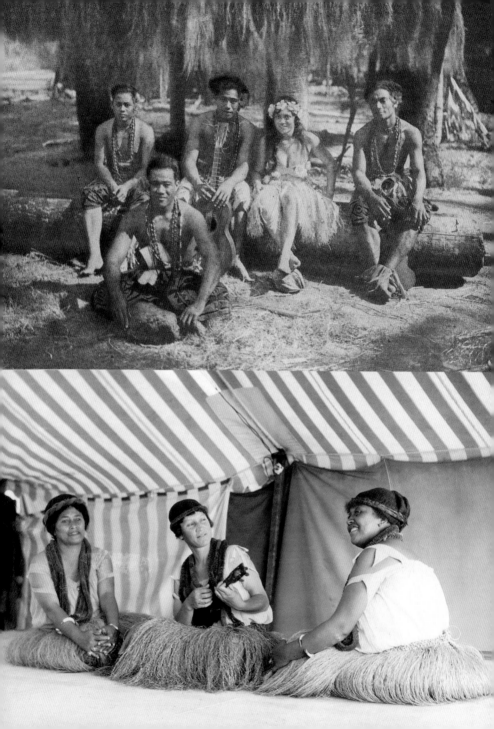

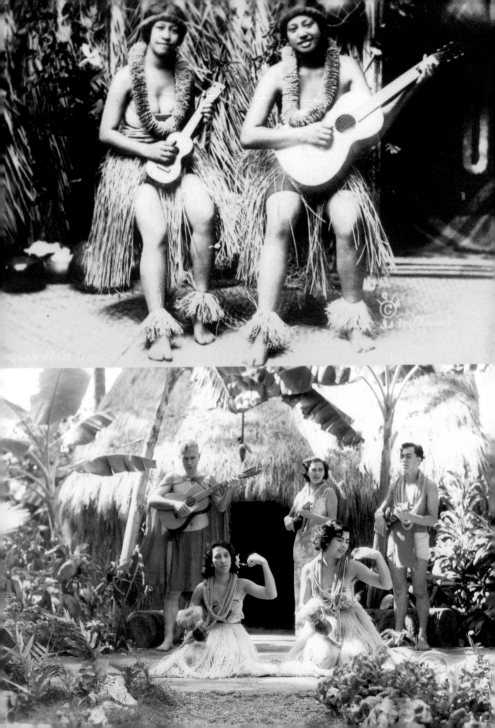

ALOMA
OF THE
SOUTH SEAS

ROBERTS PHOTO

Based upon
the Photoplay
Starring
GILDA GRAY
A Maurice
Tourneur
Production
A Paramount
Picture

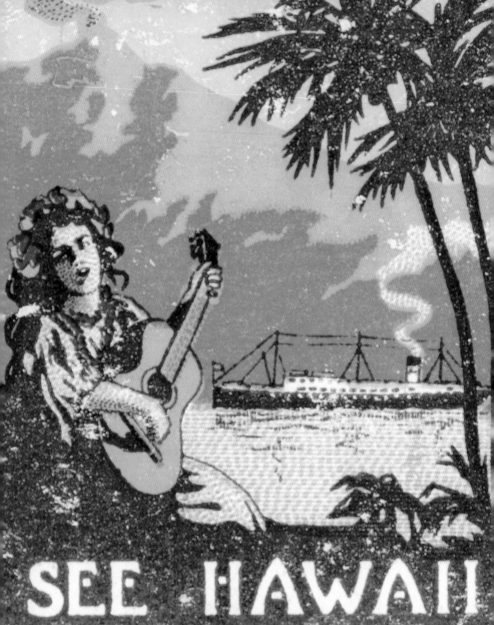

SEE HAWAII
MATSON NAVIGATION CO
SAN FRANCISCO - HONOLULU
DIRECT TO VOLCANO

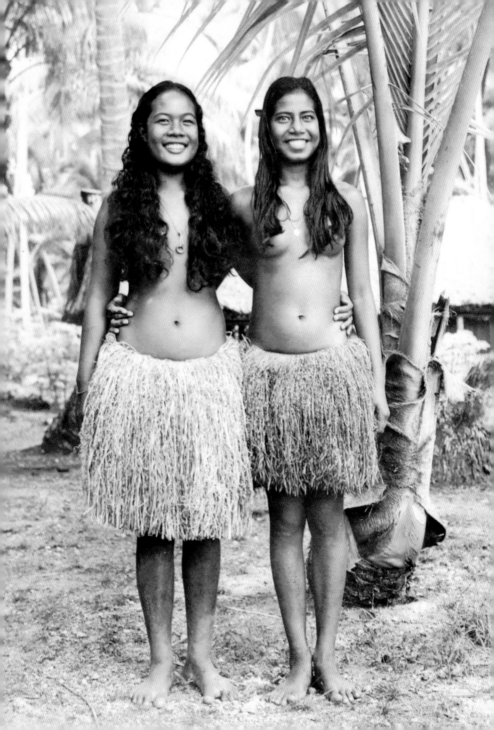

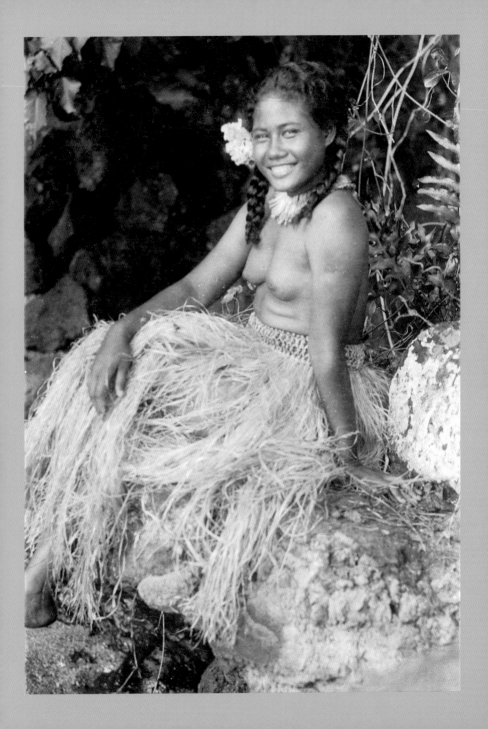

- KA'HOLO'MOANA -

The **HULA**

Interpreted — *Illustrated*

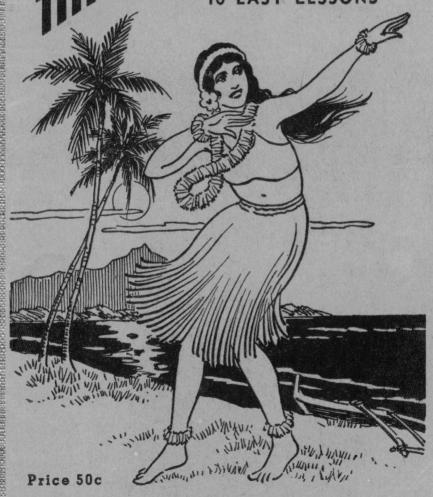

The
HAWAIIAN HULA

COMPLETE IN
10 EASY LESSONS

Price 50c

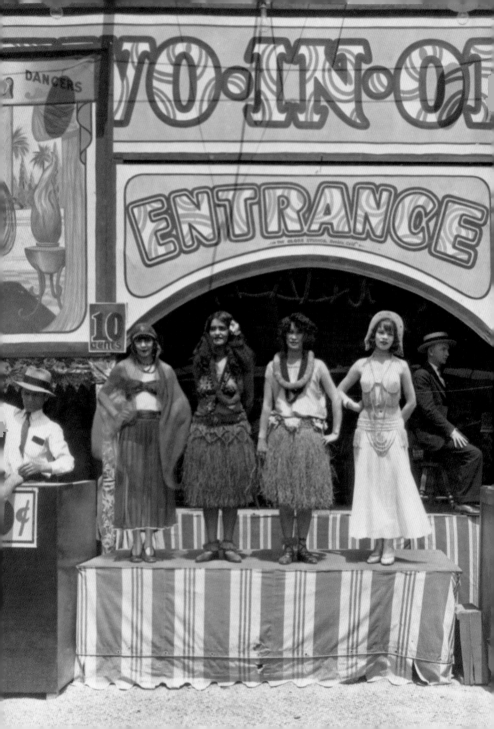

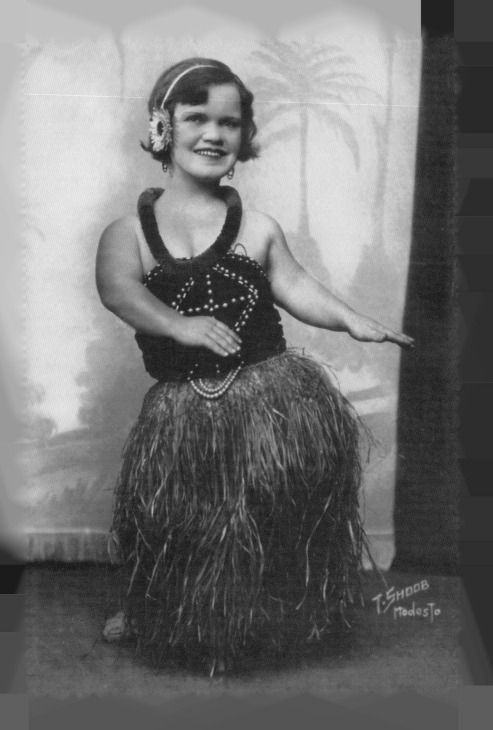

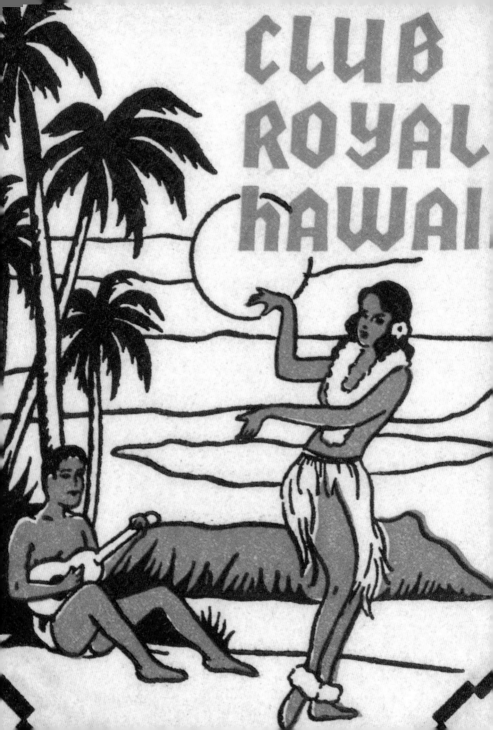

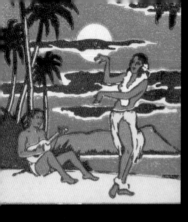

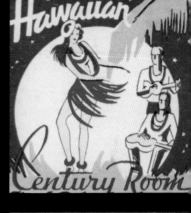
Hawaiian
Century Room

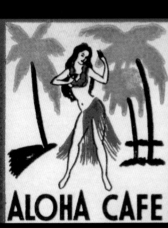
ALOHA CAFE

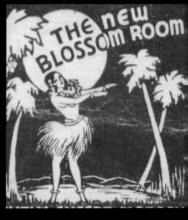
THE new
BLOSSOM ROOM

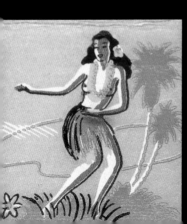

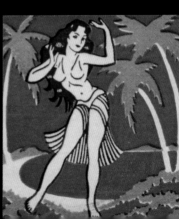

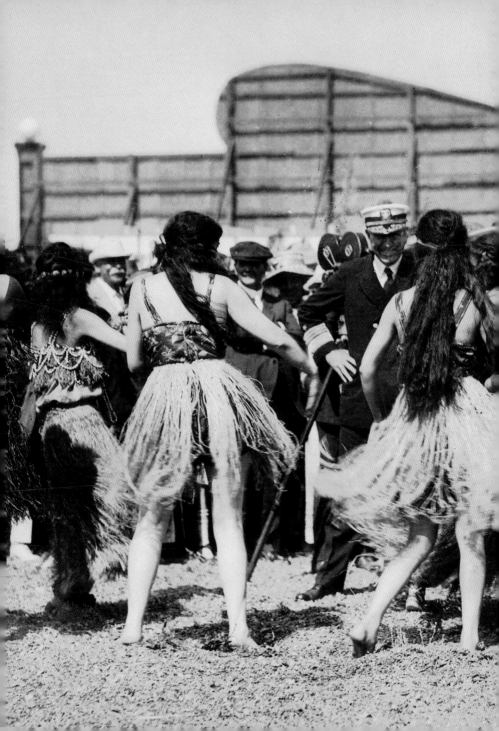

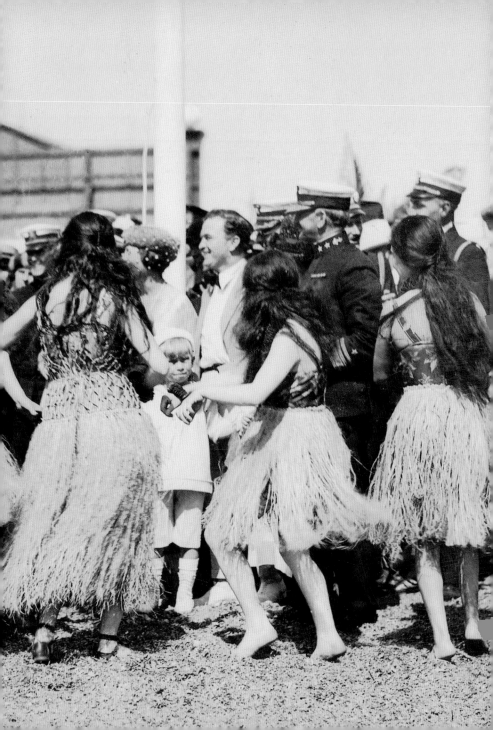

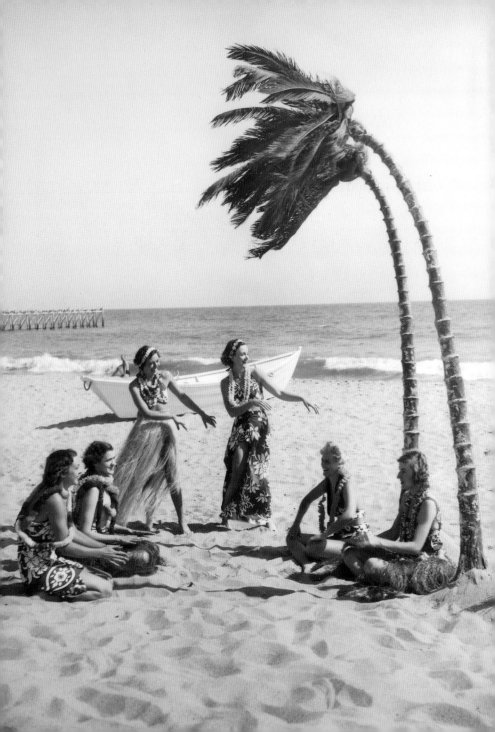

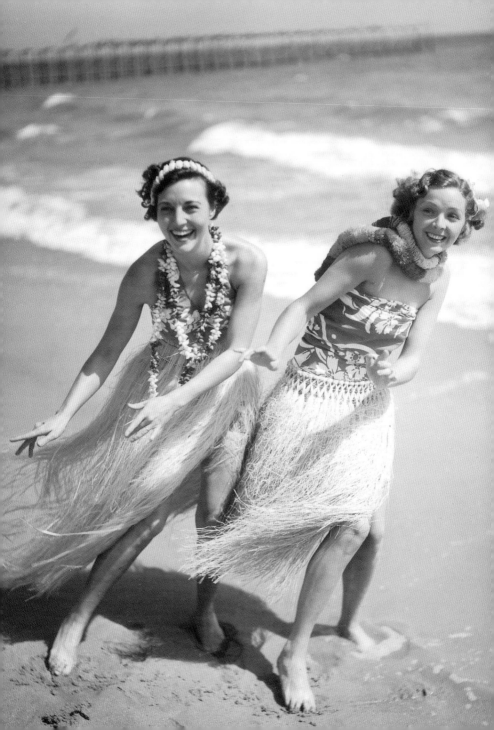

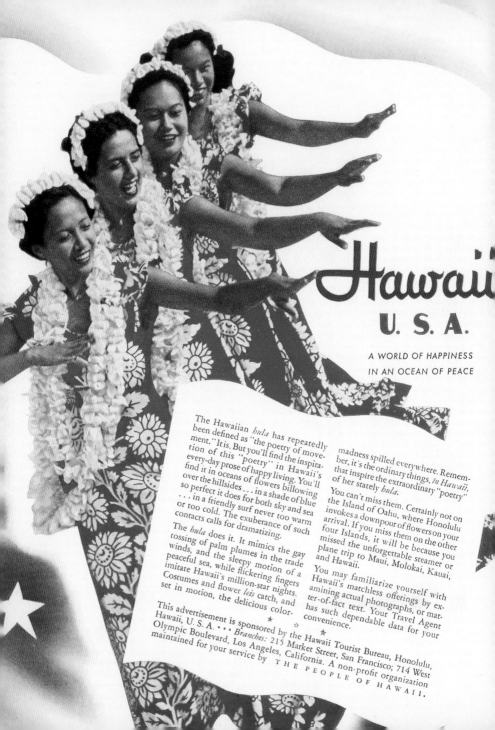

Midway

PICTURE PAPER OF PORTABLE AMUSEMENTS

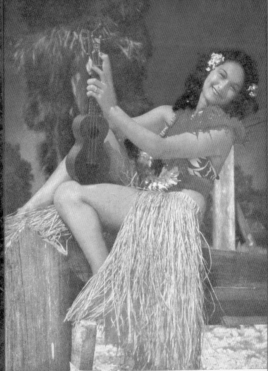

LUCCA NEWAHINI, ROYAL AMERICAN "IMPERIAL HAWAIIAN" STAR

15¢

BY THE COPY

1939 FAIR ROUTES

AMUSEMENT CORPORATION of AMERICA SHOWS

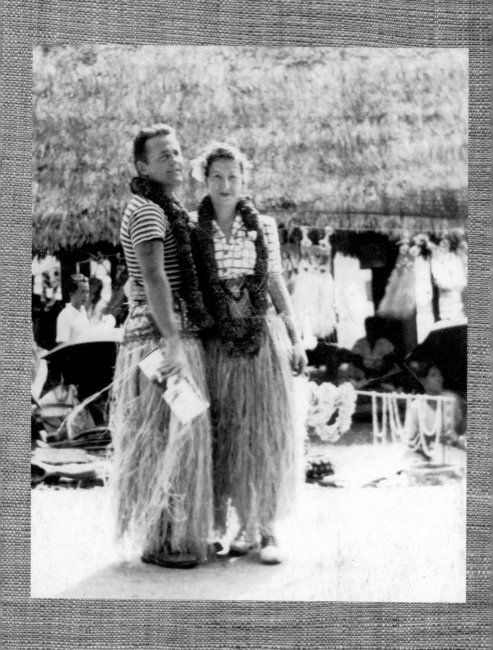

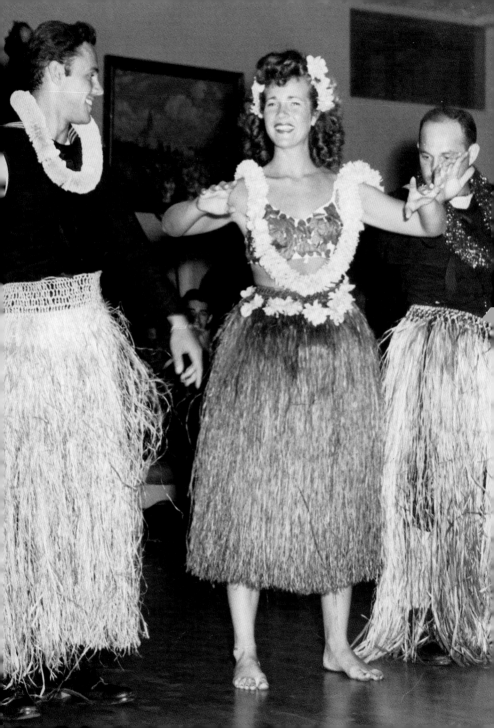

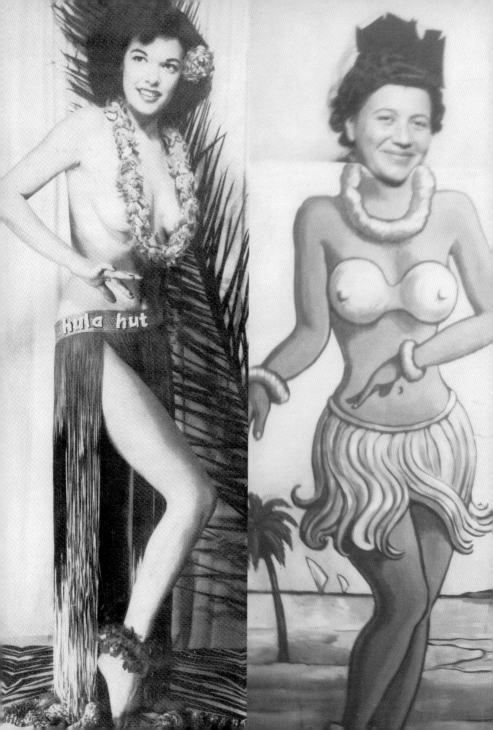

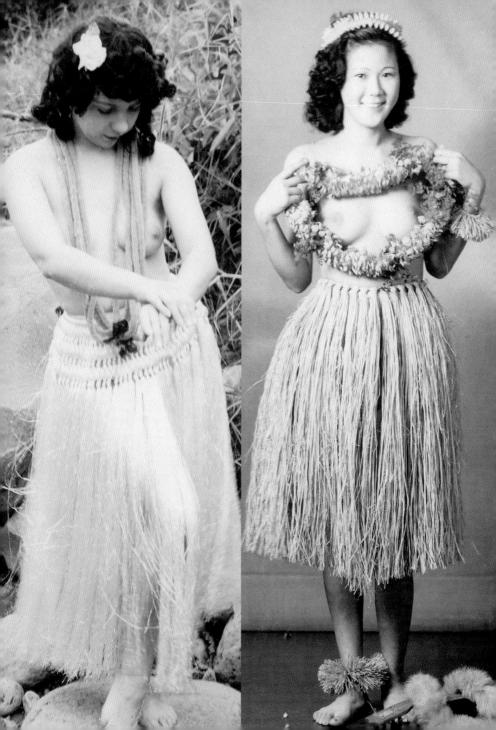

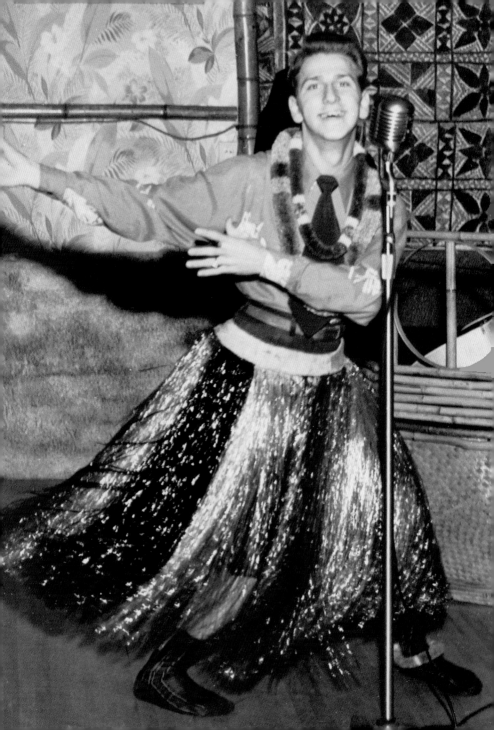

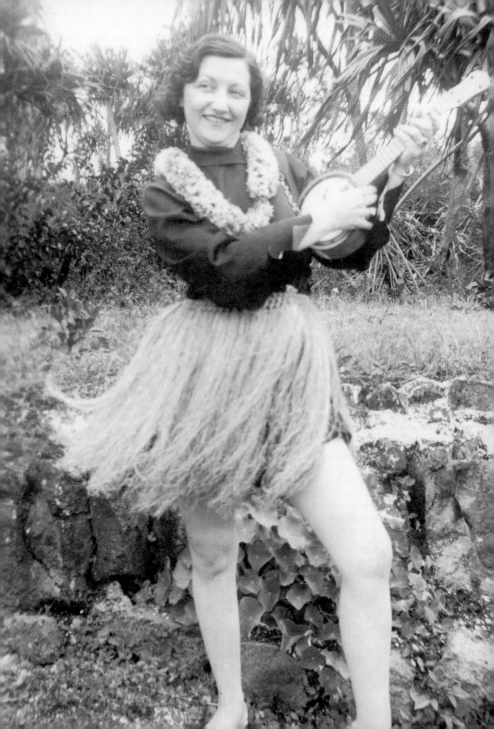

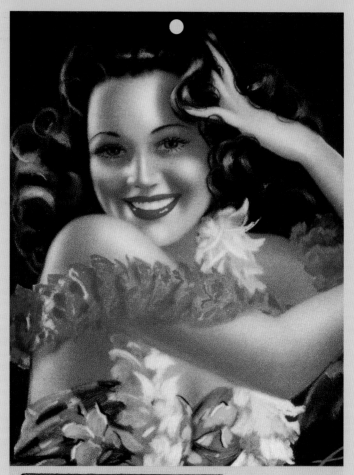

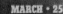

MARCH · 25¢

Hearst's International

COMBINED WITH

Cosmopolitan

TALES OF SIX CITIES *by* **PAUL GALLICO**

NOBODY EVER DIES *by* **ERNEST HEMINGWAY**

NIGHT CLUB LADY – A COMPLETE BOOK-LENGTH NOVEL

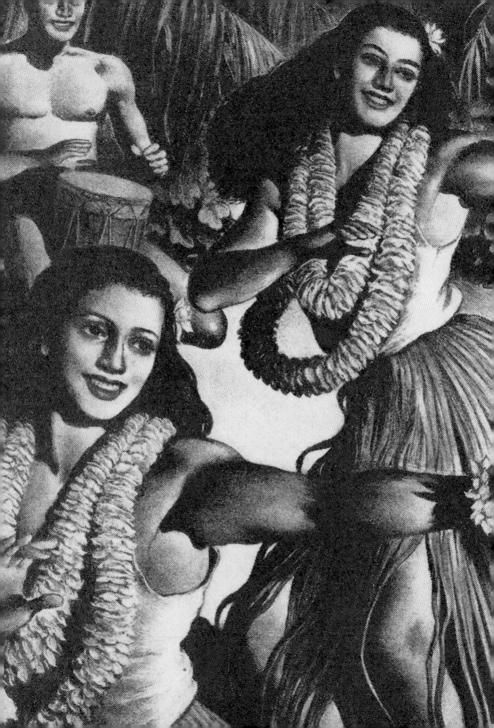

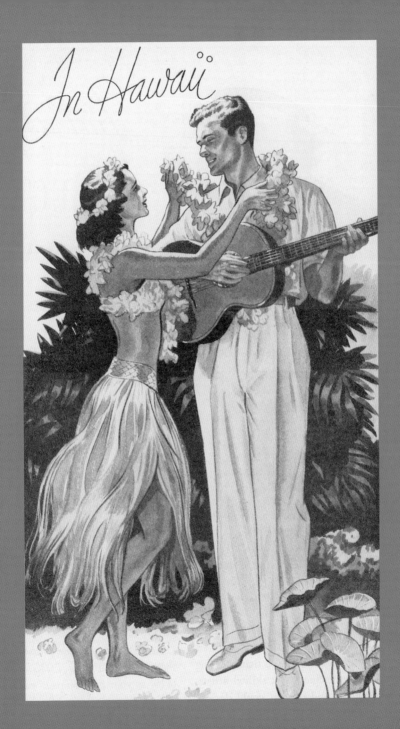

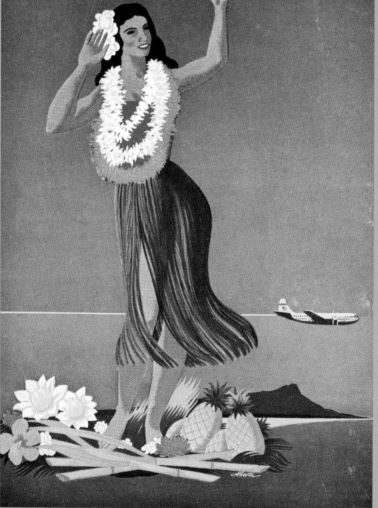

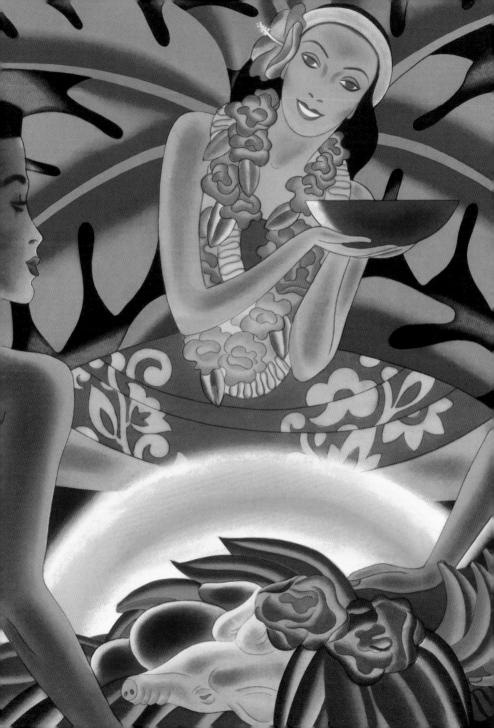

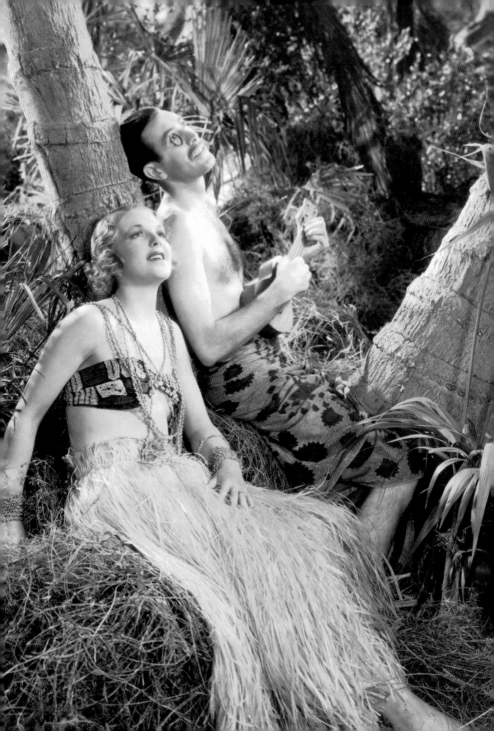

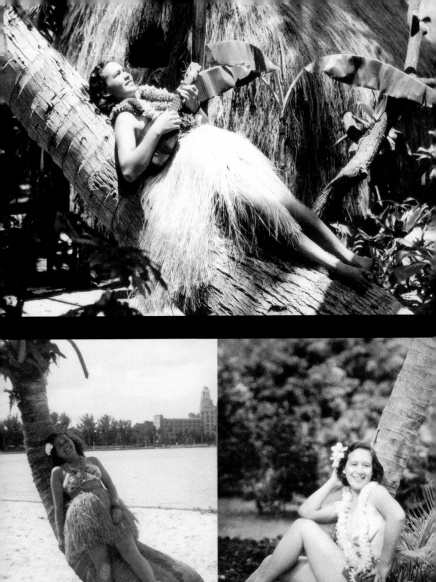
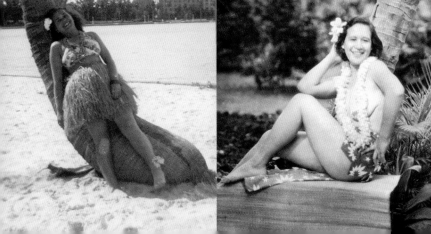

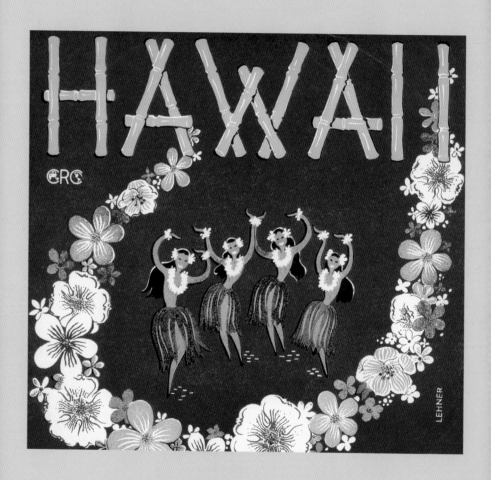

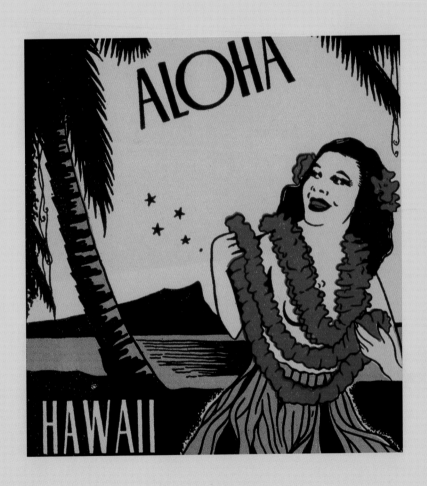

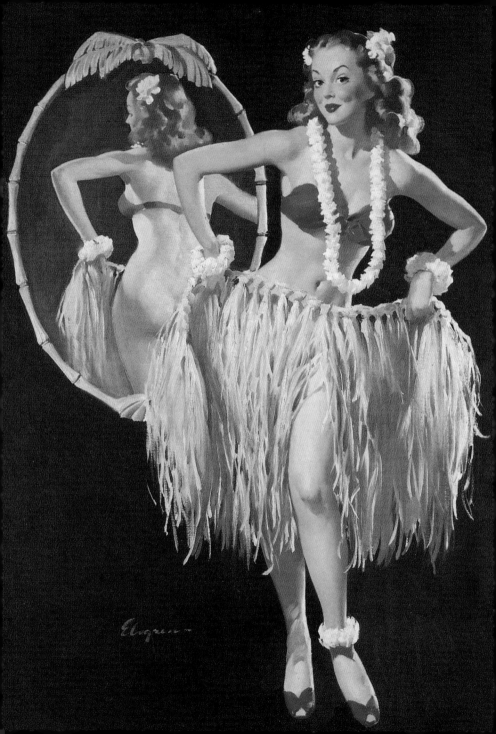

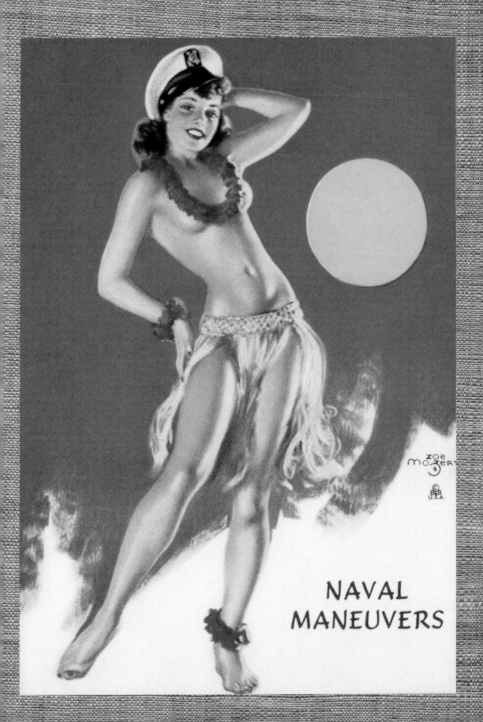

NAVAL
MANEUVERS

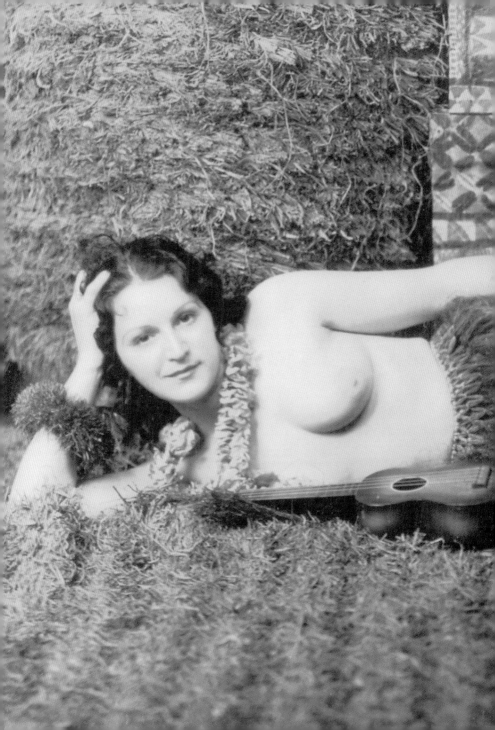

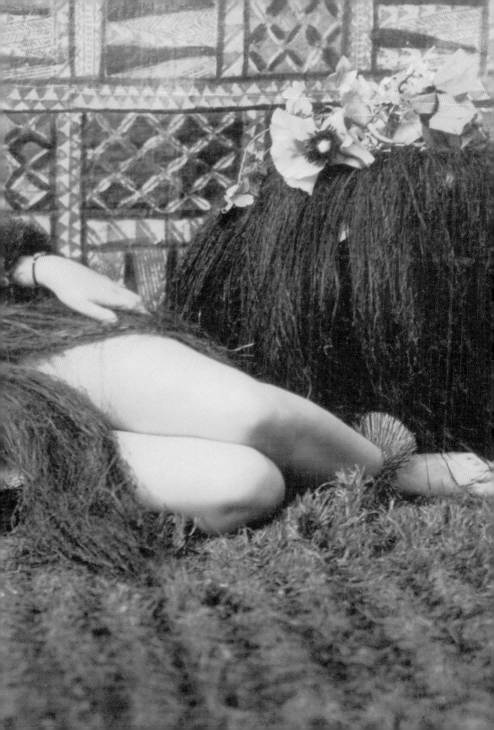

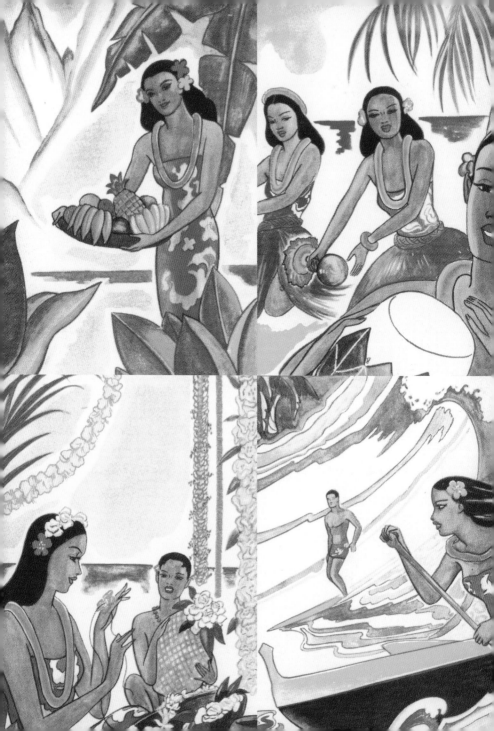

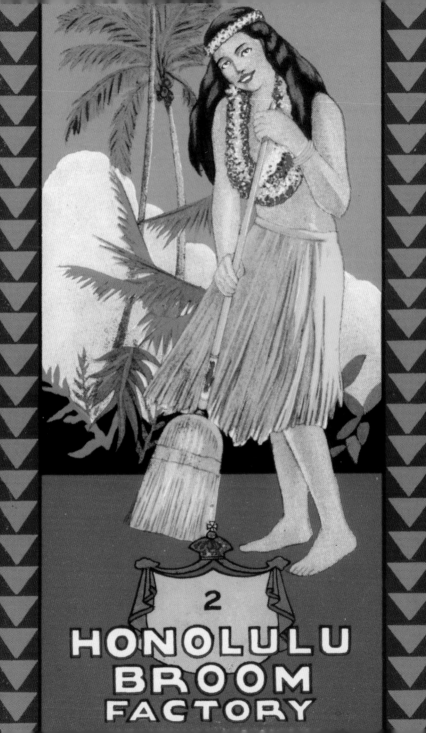

2

HONOLULU
BROOM
FACTORY

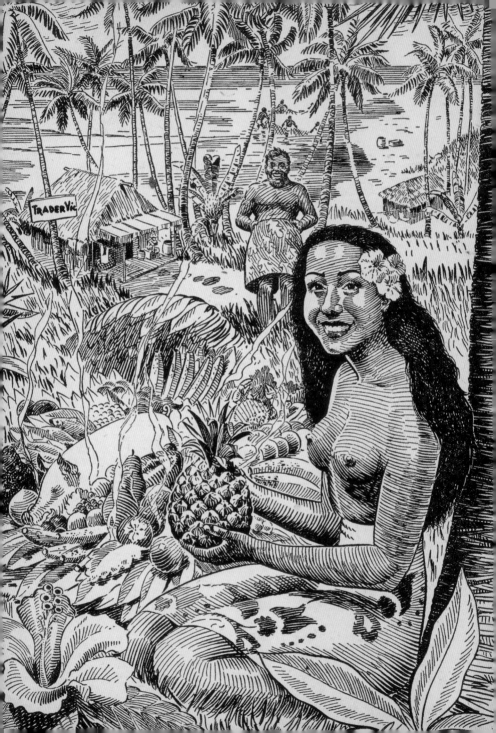

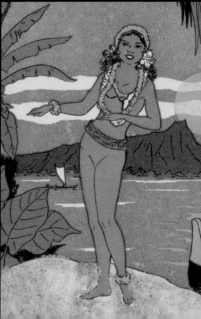

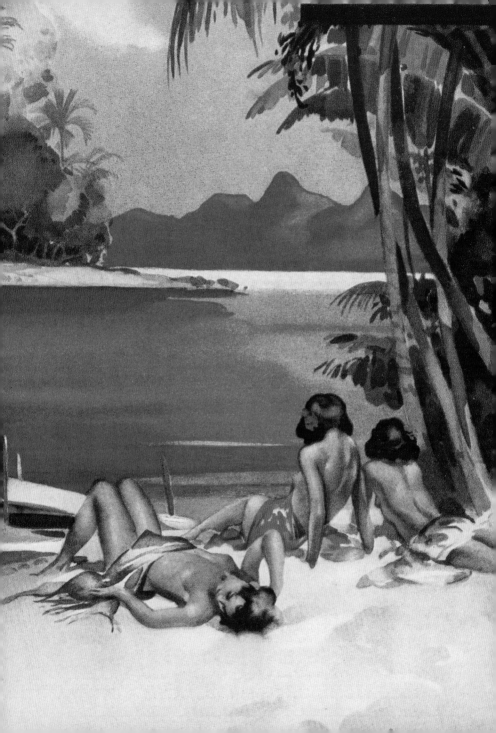

HOOEY

MAY 15c

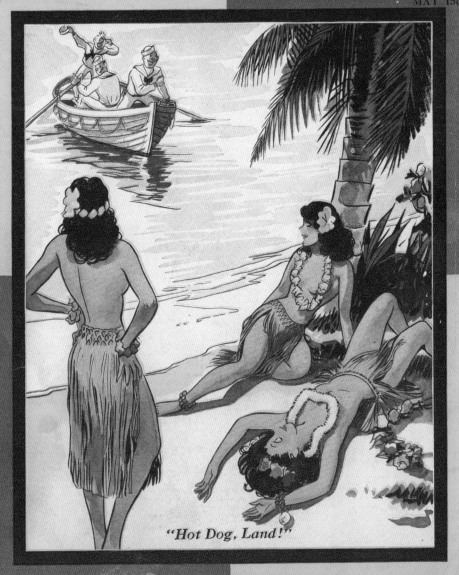

"Hot Dog, Land!"

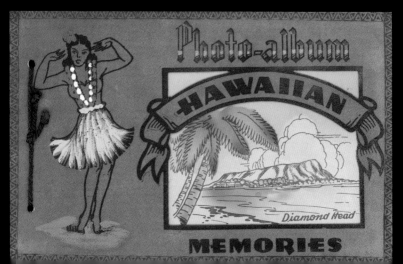

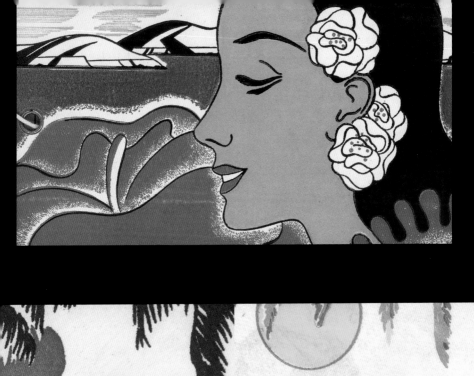

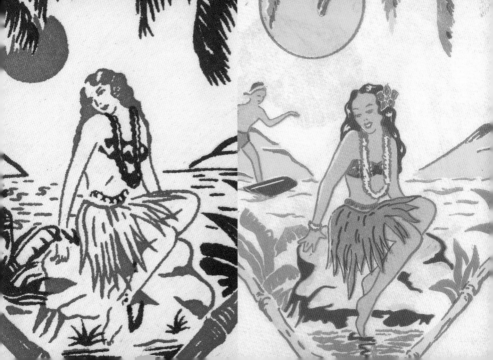

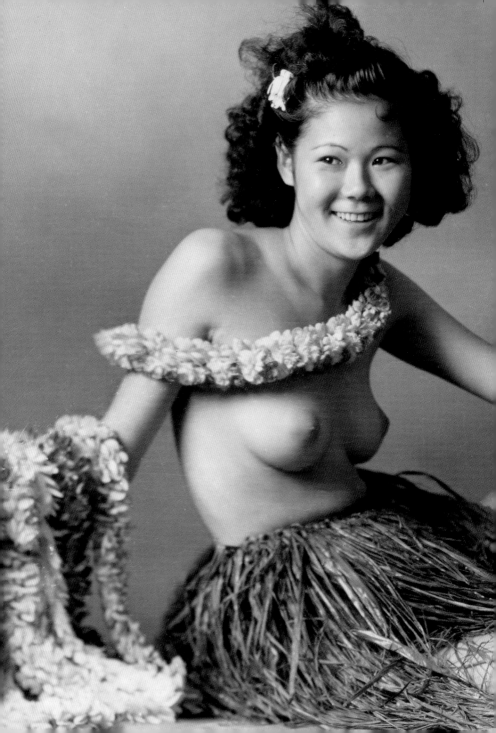

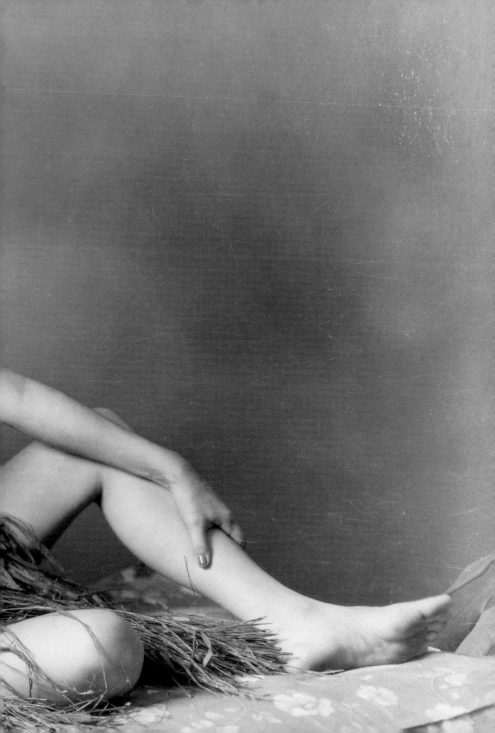

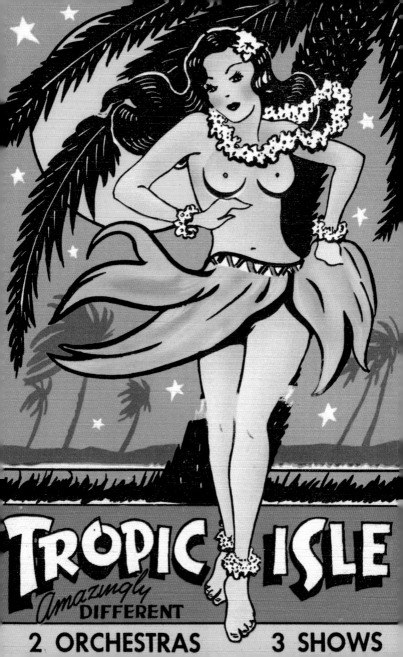

ALOHA
HAWAII

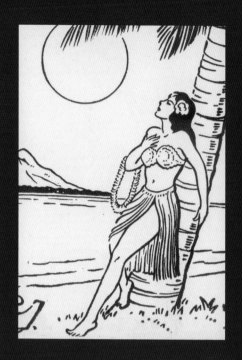

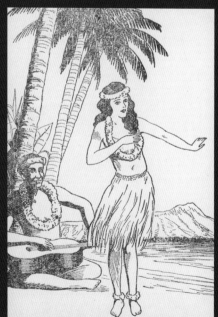

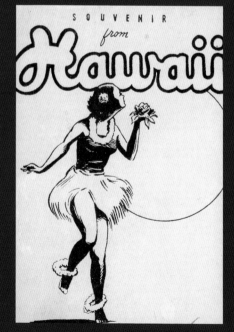

SOUVENIR
from
Hawaii

Speak HAWAIIAN

Words - Toasts - Phrases

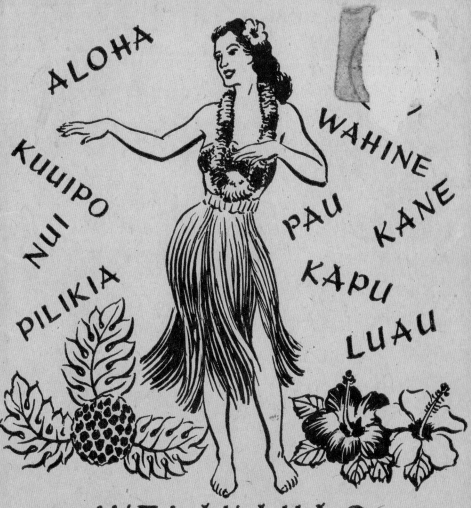

ALOHA

WAHINE

KUUIPO

PAU

KANE

NUI

KAPU

PILIKIA

LUAU

WELAKAHAO

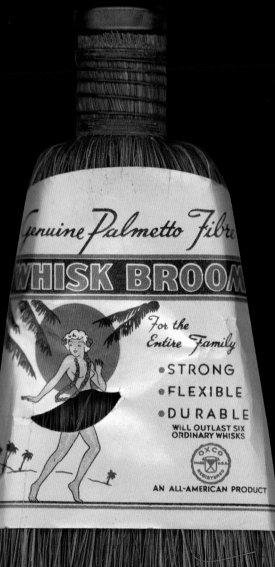

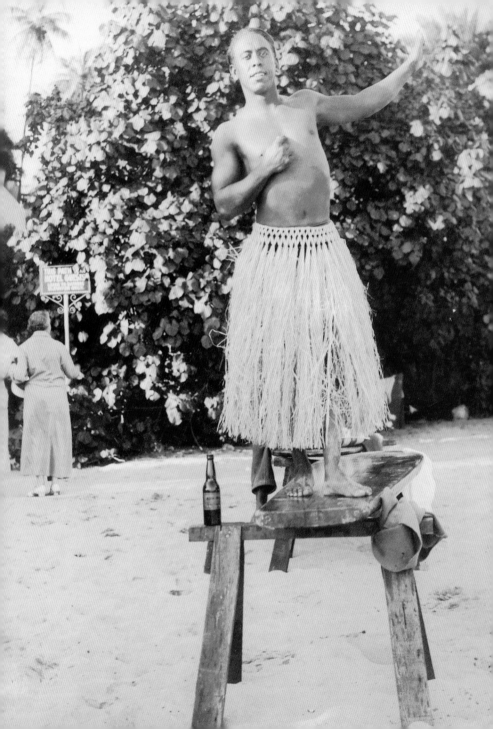

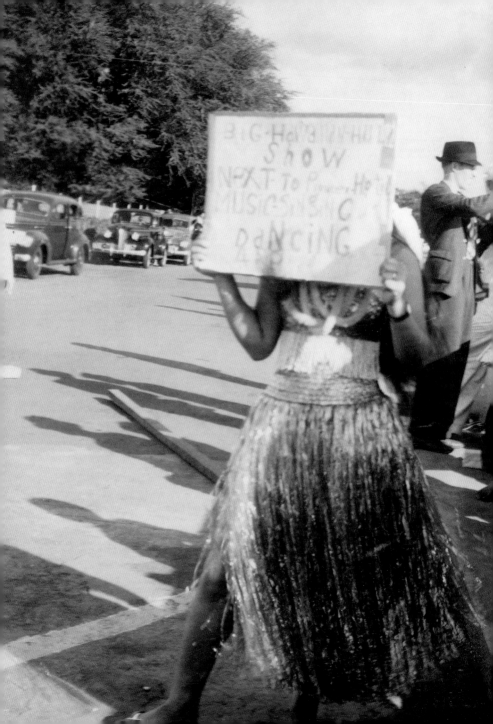

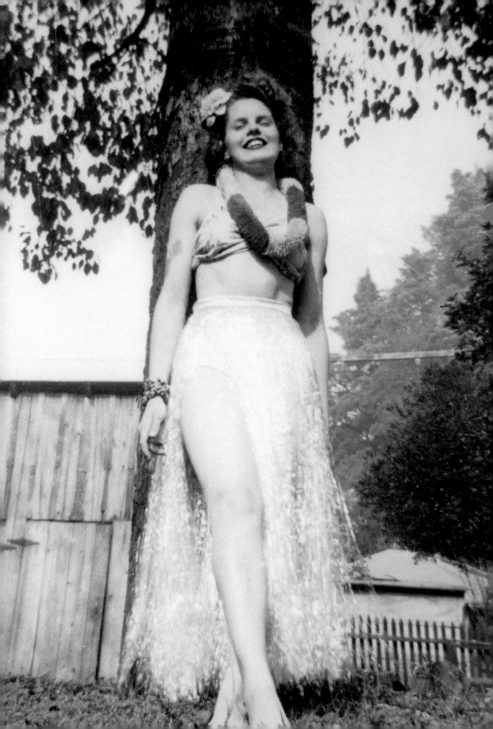

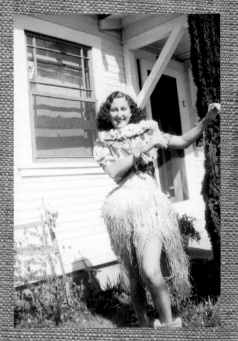
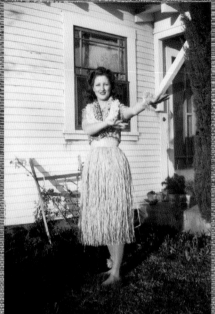
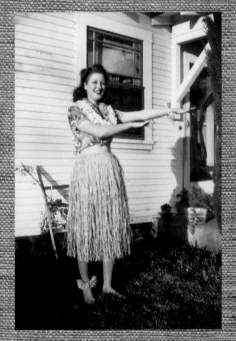
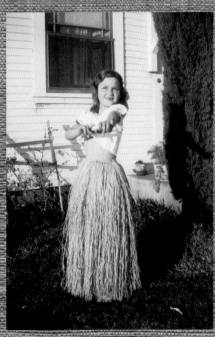

Hawaiian
BLUE ROOM

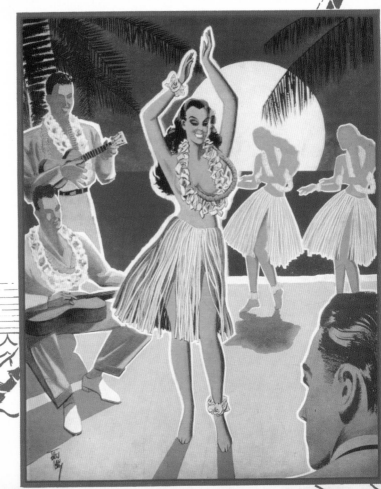

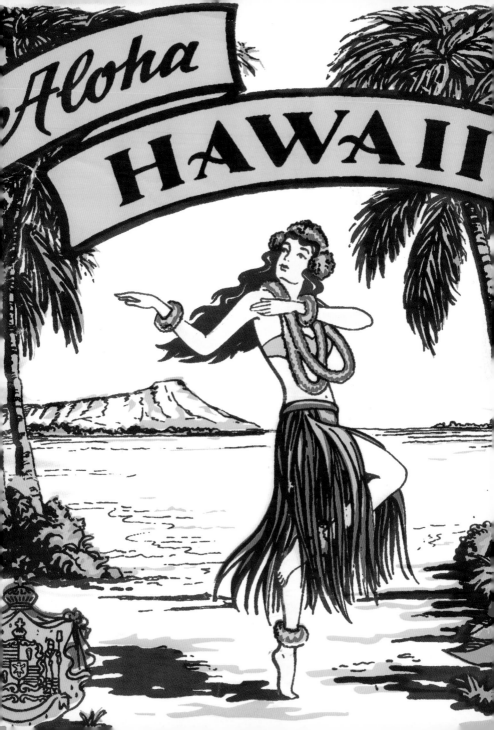

THE HULA

The Dance and its Meaning

By MARTHA HOMSY

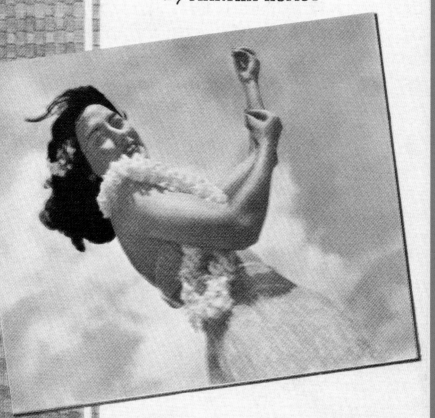

TONGG PUBLISHING COMPANY, Honolulu Hawaii

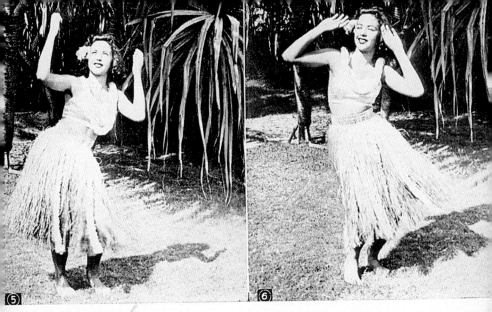

5. Ko maka e
 your eyes

7. Ko papalina
 your cheeks

6. e no weo nei
 how they do sparkle

8. e kuku ana
 how plump and rosy.

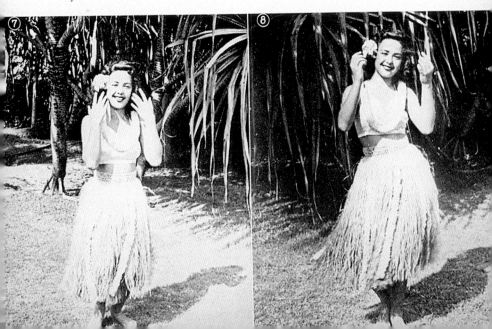

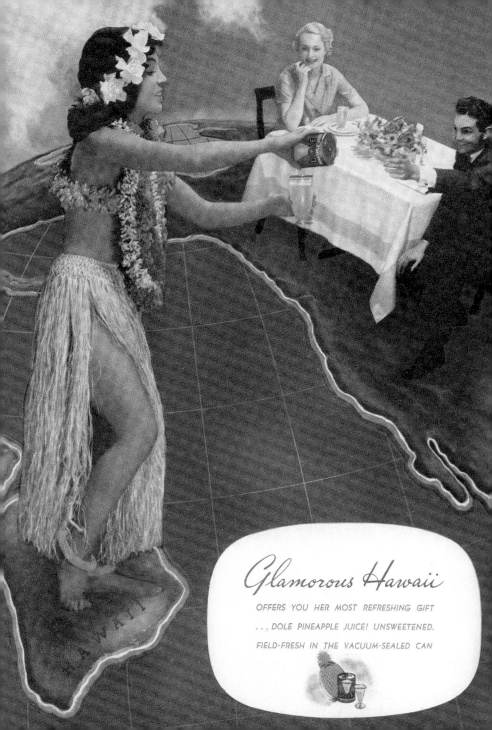

Glamorous Hawaii

OFFERS YOU HER MOST REFRESHING GIFT
. . . DOLE PINEAPPLE JUICE! UNSWEETENED.
FIELD-FRESH IN THE VACUUM-SEALED CAN

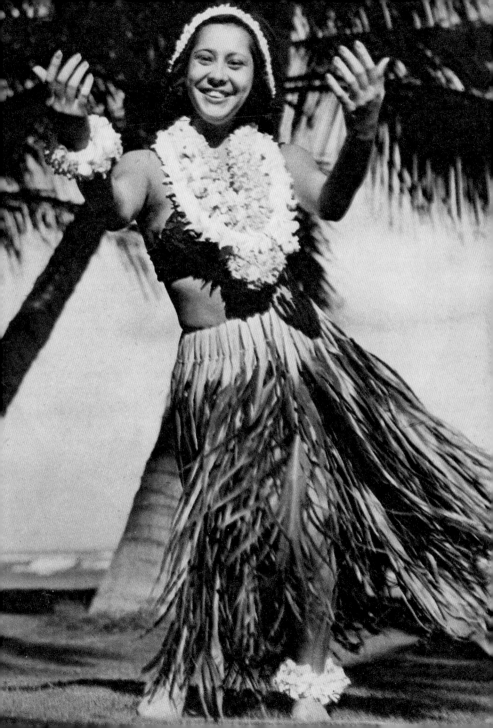

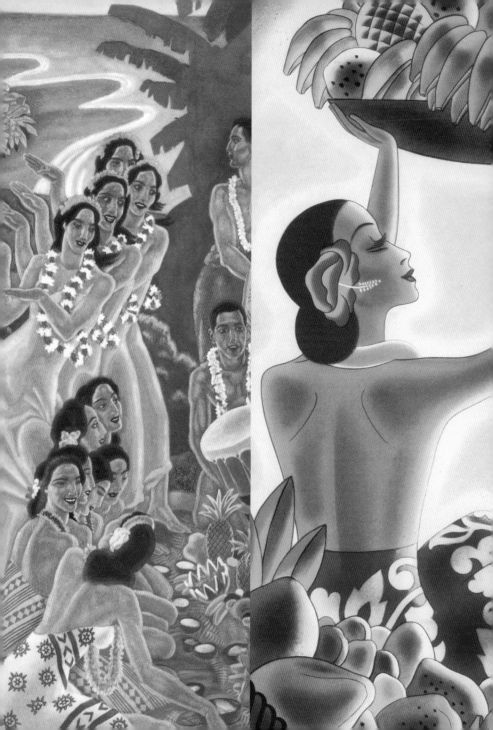

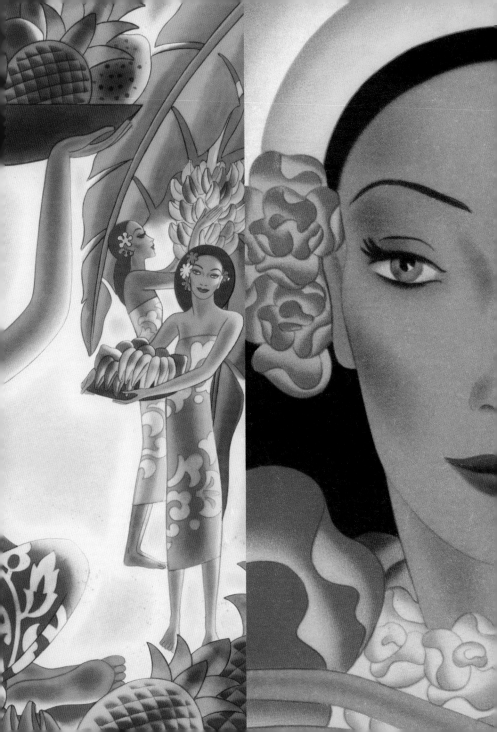

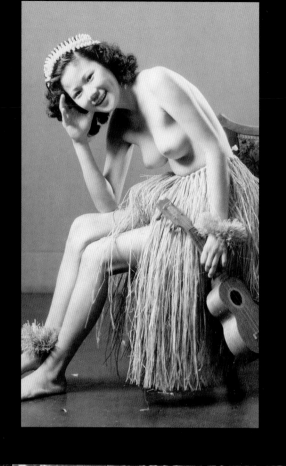
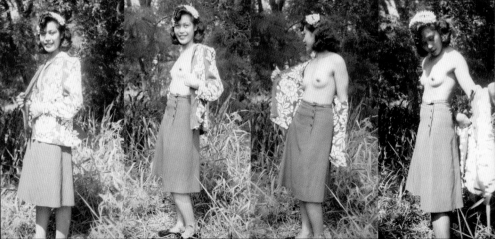

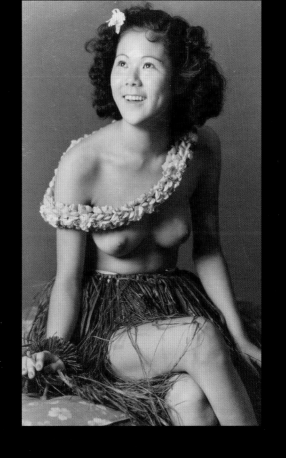
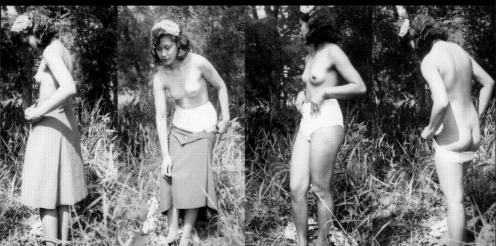

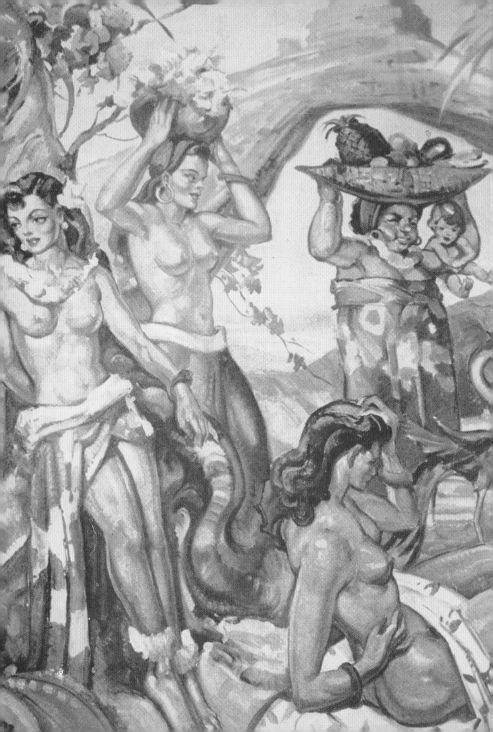

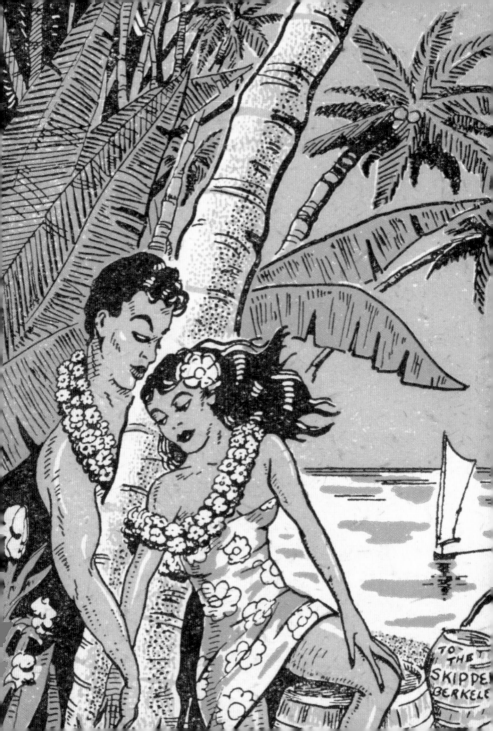

HULA

BRAND ®

ORIENTAL TYPE
ALIMENTARY PASTE PRODUCT

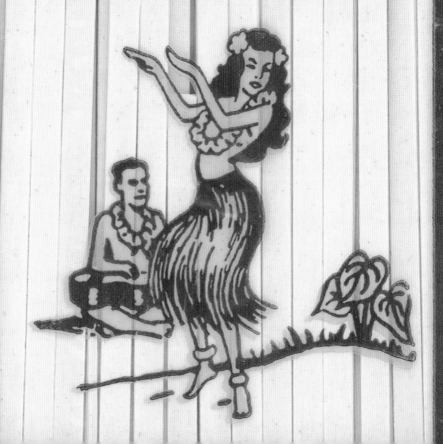

BAMBU HUT

"Lure of the Tropics"

THE HUR

San Fran

BERT ROVERE

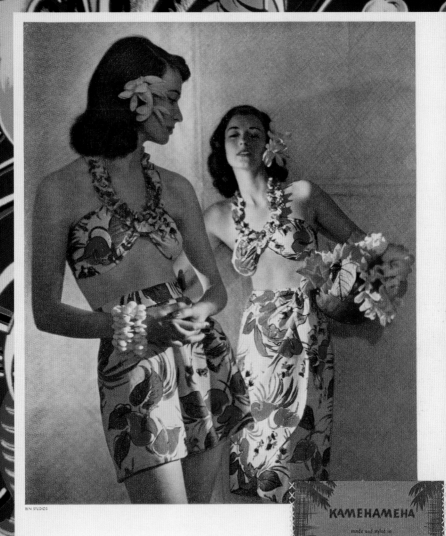

BEN STUDIOS

Aloha ... Hawaii !

That word on the label is pronounced Ka-may-ha-may-ha (it's the name of Hawaii's
greatest King) ... and the playclothes are as authentic as the name. Kamehameha
fashions are *styled and made right in Hawaii* (where else is there so much inspiration for romance
under the sun?) ... of famed fabrics that thrive on sun and water. At one fine store in each city.

KAMEHAMEHA GARMENT COMPANY, Ltd. • Honolulu 2, Hawaii

KAMEHAMEHA
made and styled in
HAWAII

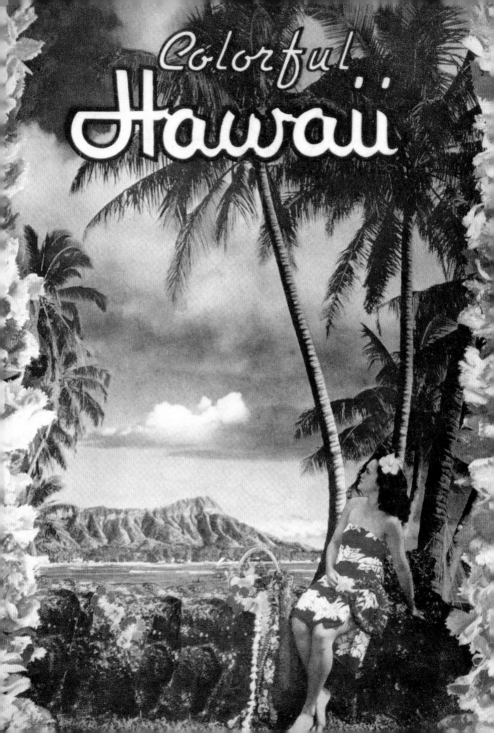

Colorful
Hawaii

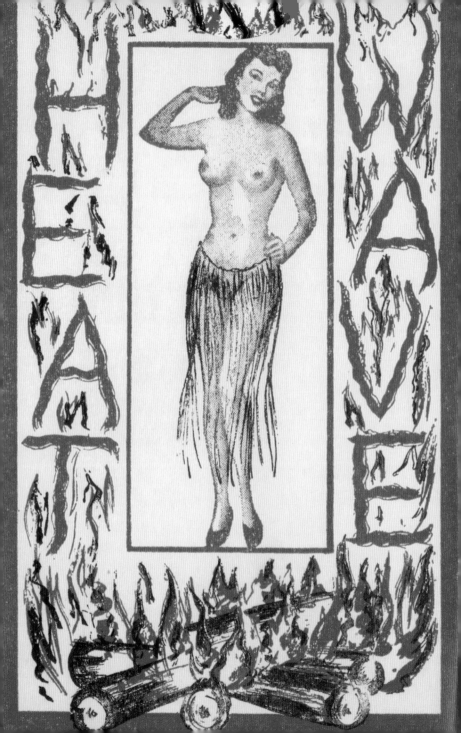

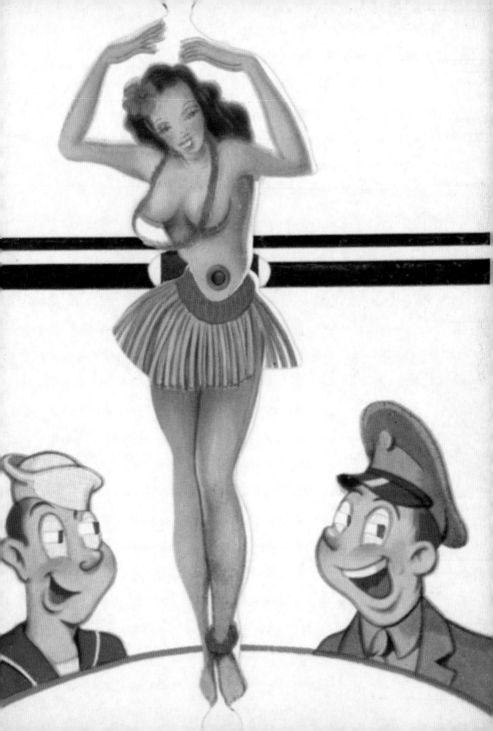

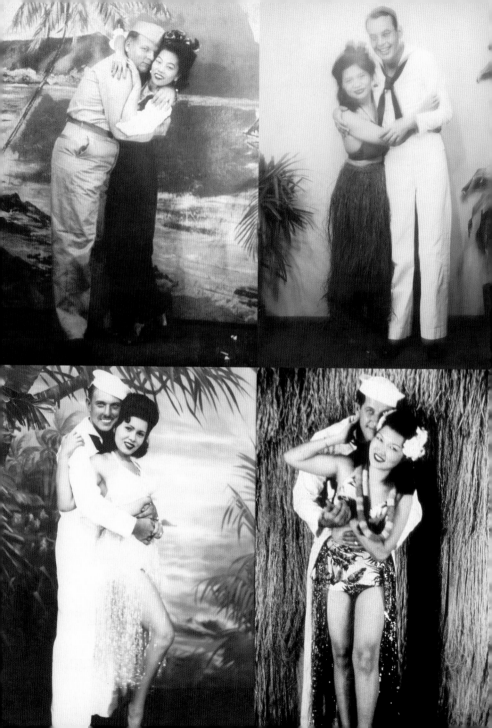

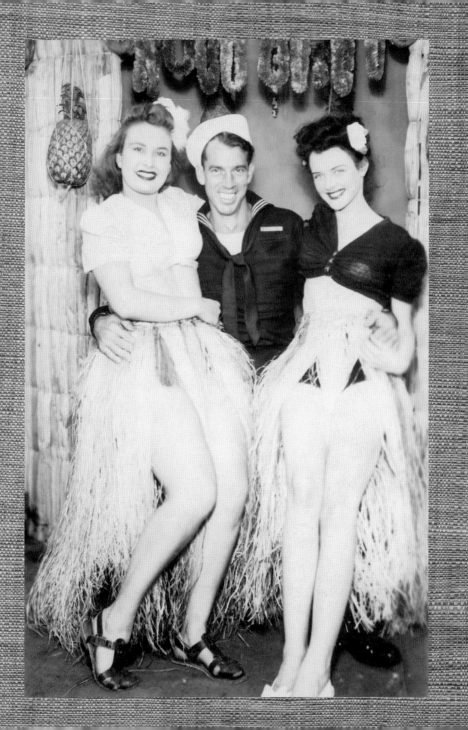

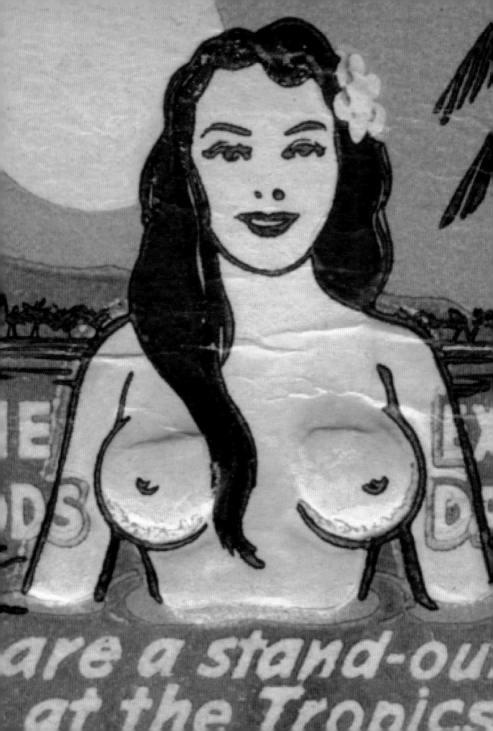

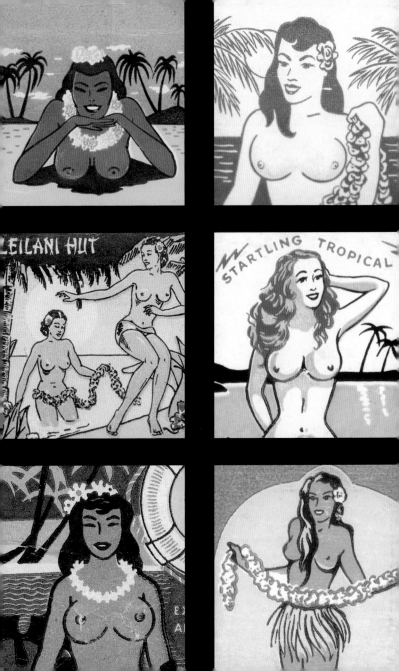

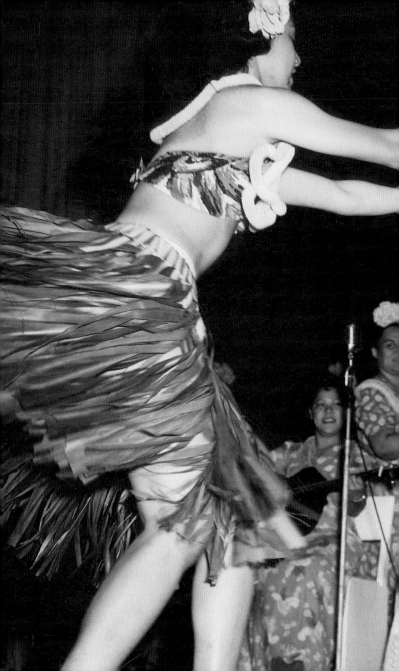

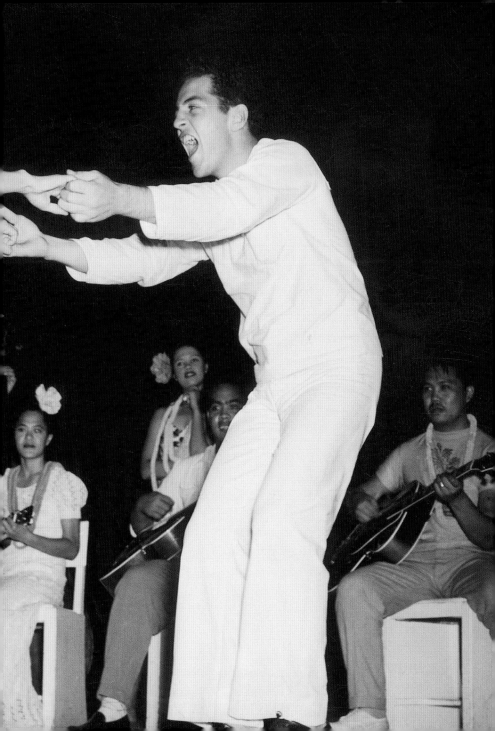

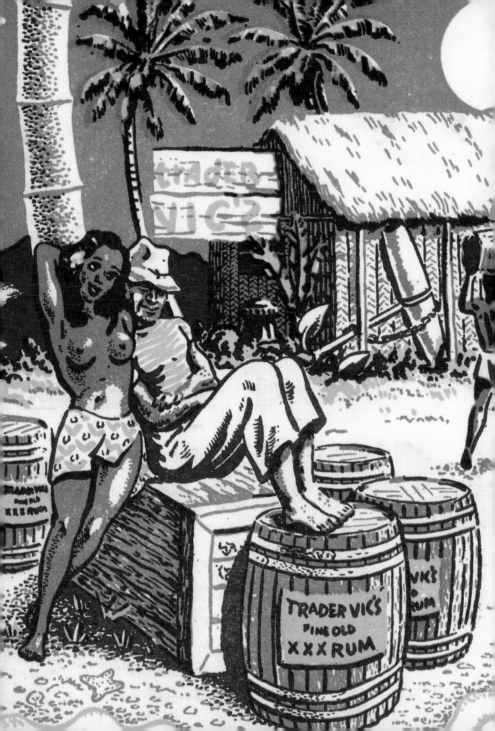

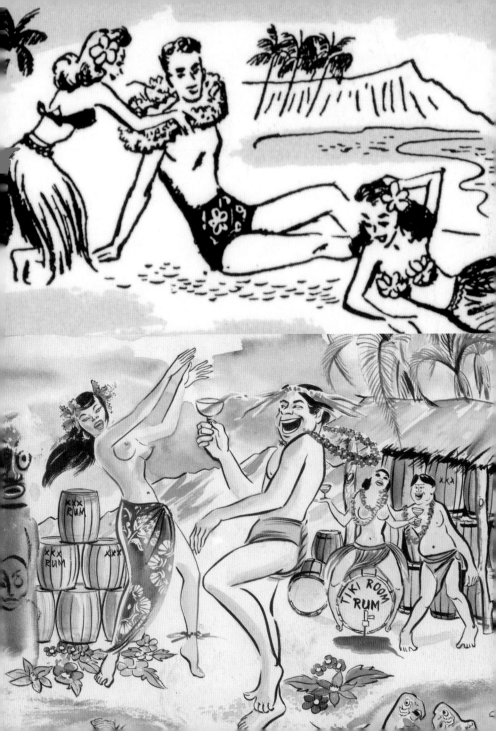

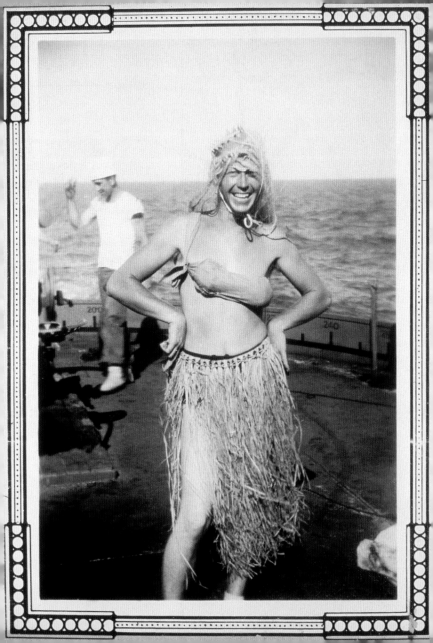

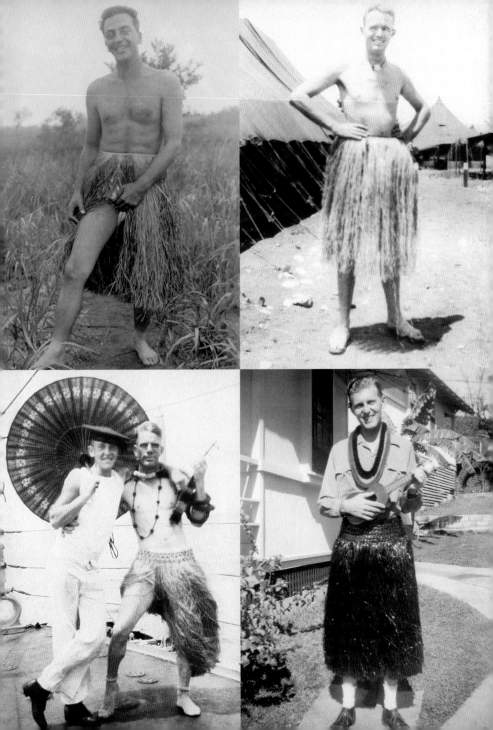

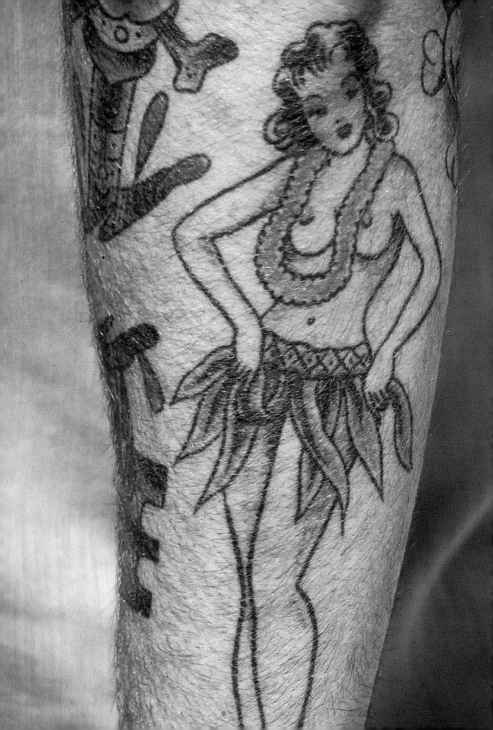

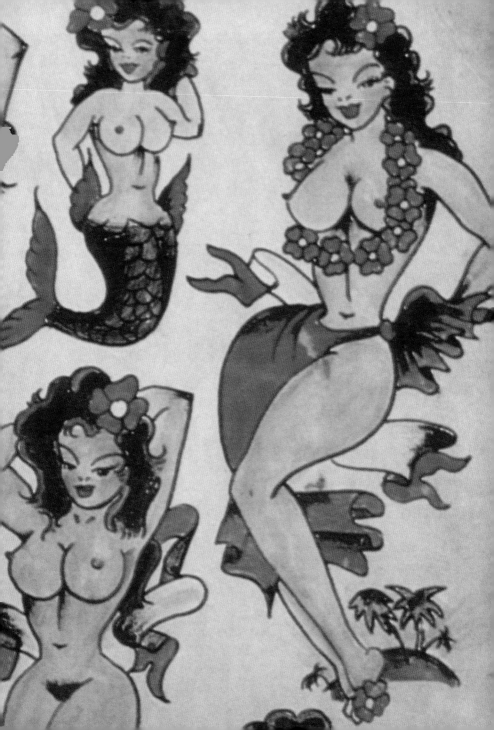

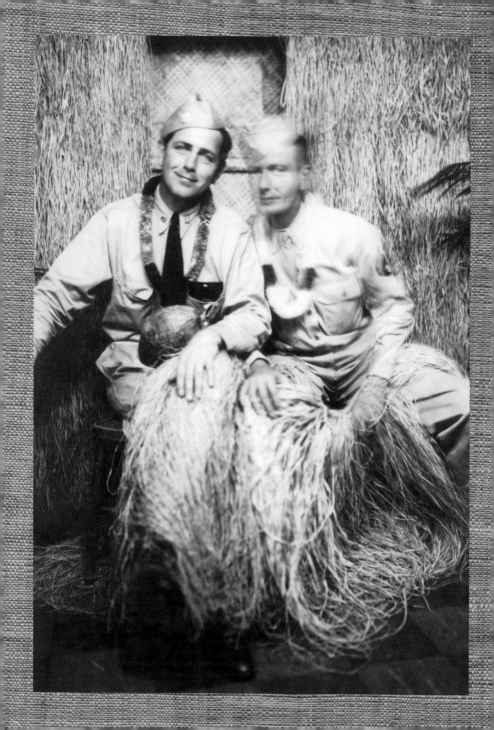

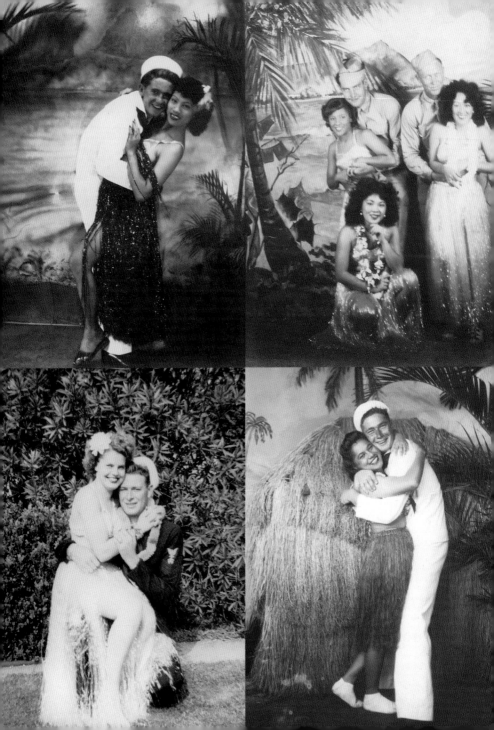

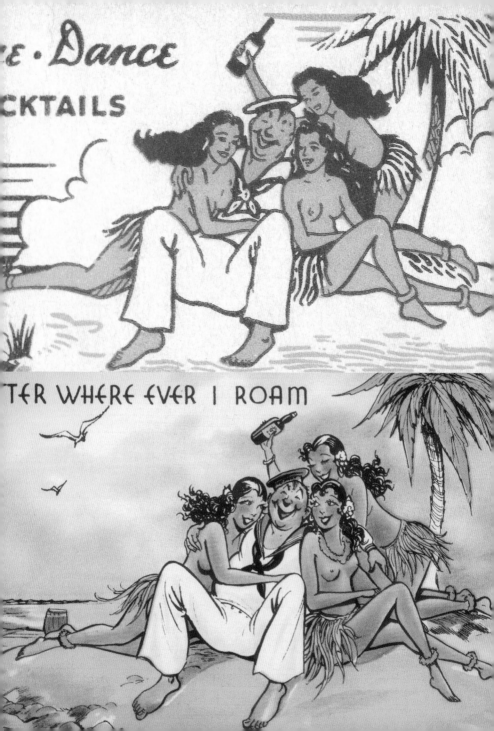

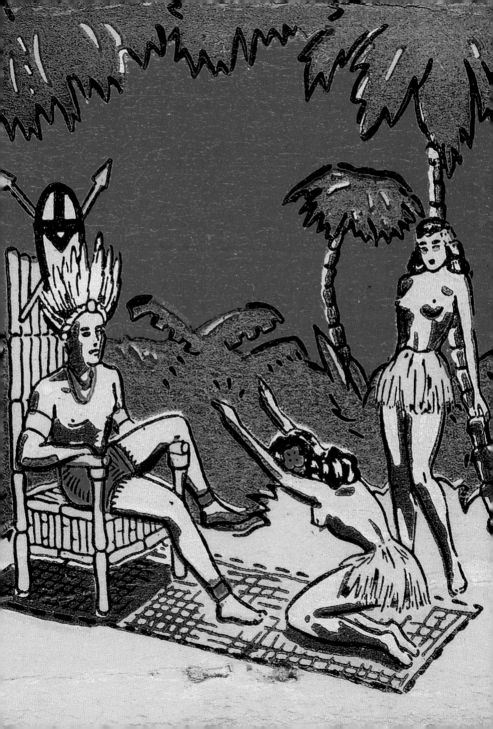

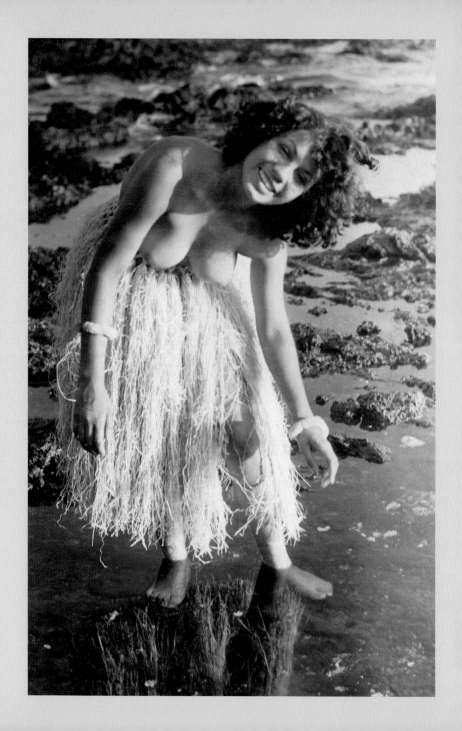

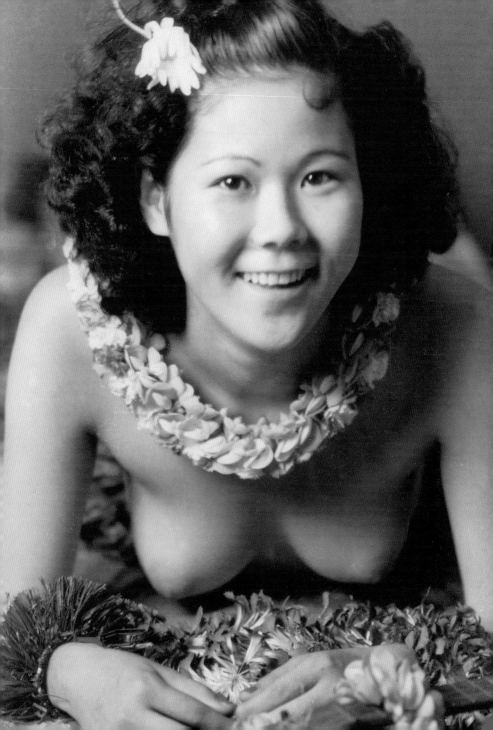

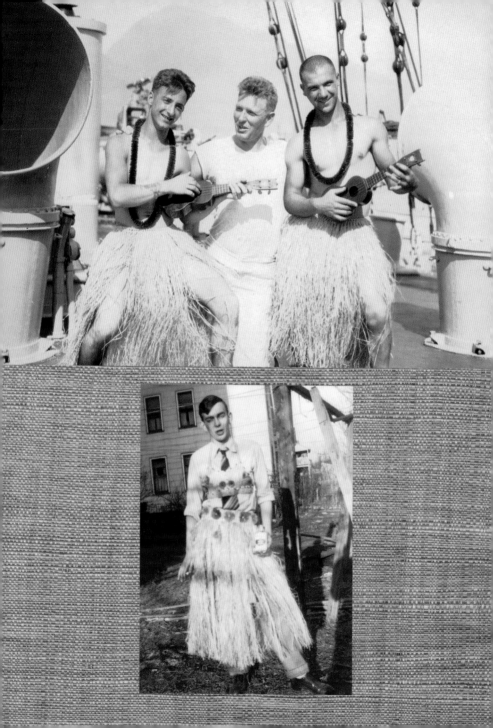

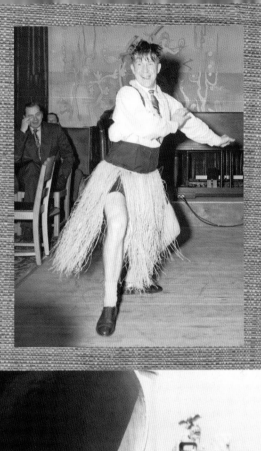

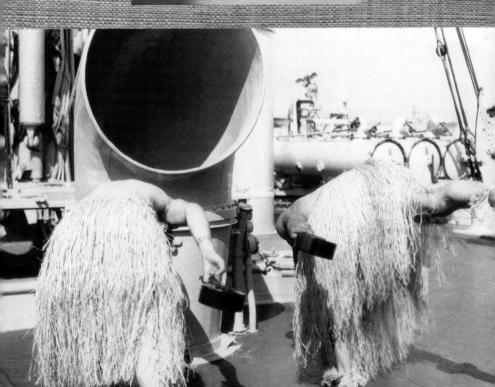

THE
ARISTOCRAT
OF NITE CLUBS

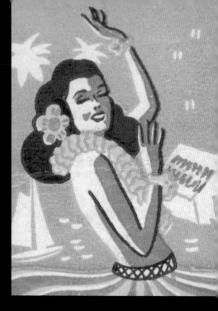

THE TROPIC
ATMOSPHERE
DOES
SOMETHIN
for EVERYBO

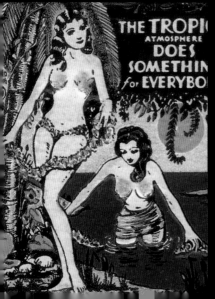

SAN FRANCISCO'S
Exclusive
COCKTAIL LOUNGE
WITH
HAWAIIAN
ATMOSPHERE

BANQUET ROOM
FOR
PRIVATE PARTIES

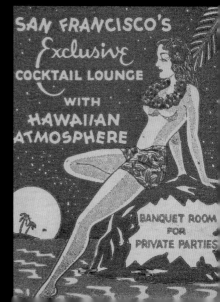

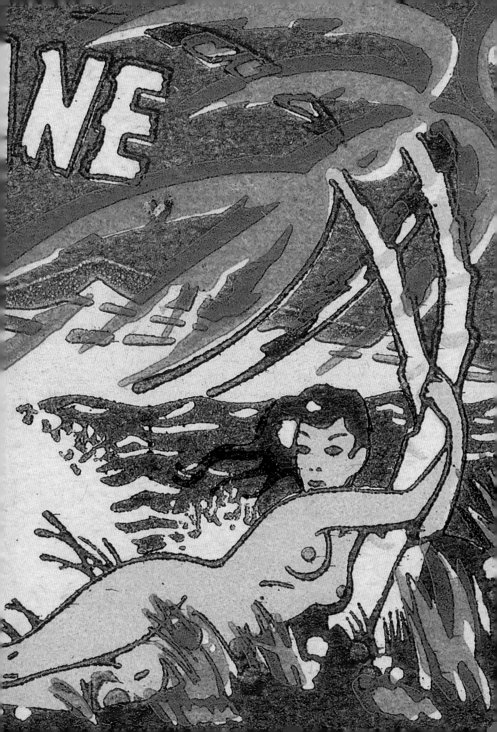

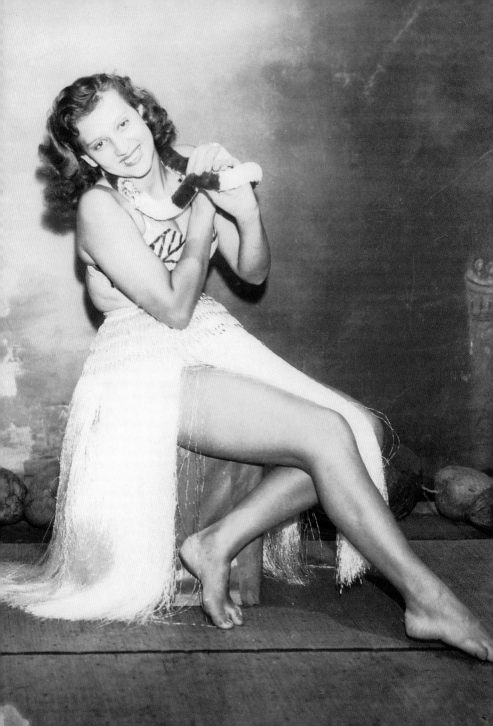

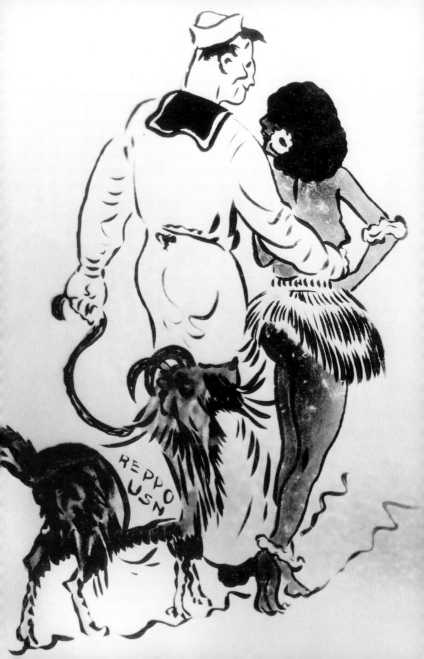

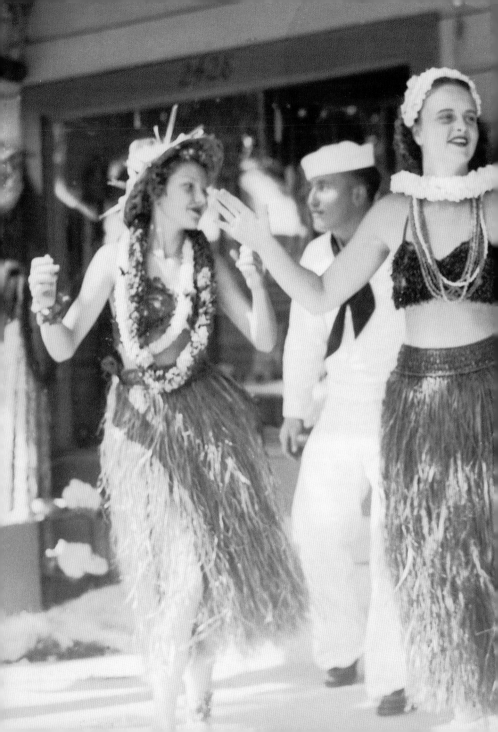

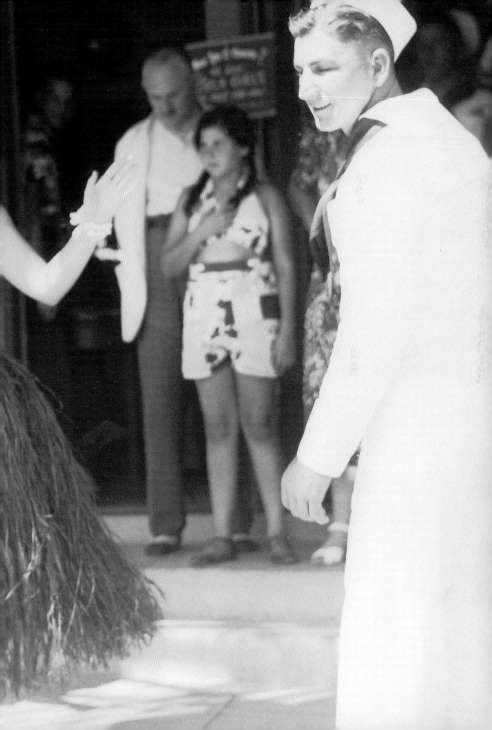

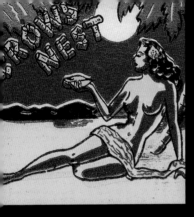

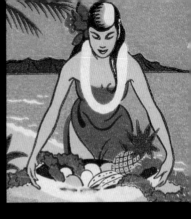

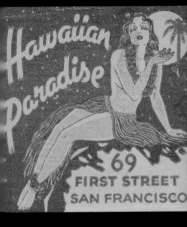

Hawaiian Paradise

69
FIRST STREET
SAN FRANCISCO

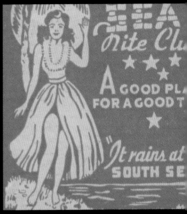

SEA
Nite Club
★ ★ ★
A GOOD PLA
FOR A GOOD T
★
"It rains at
SOUTH SE

Gene's
HAWAIIAN
VILLAGE

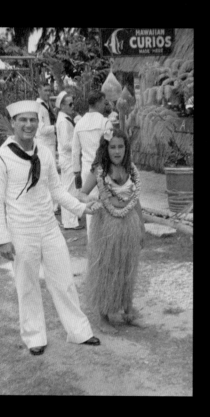
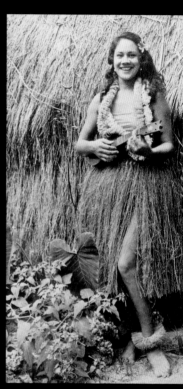

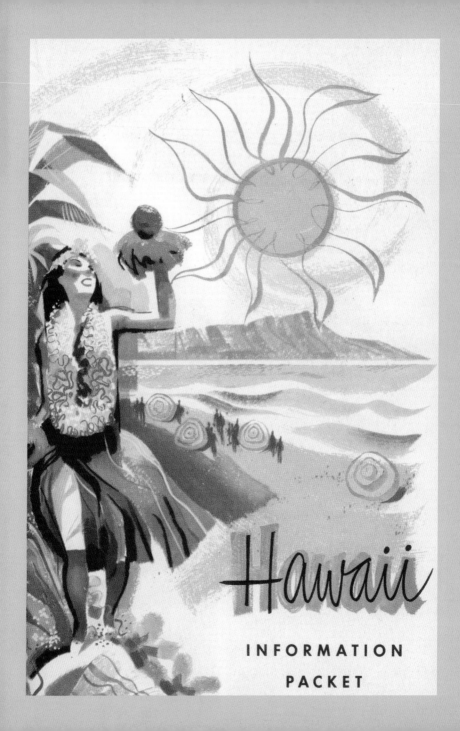

Hawaii

INFORMATION
PACKET

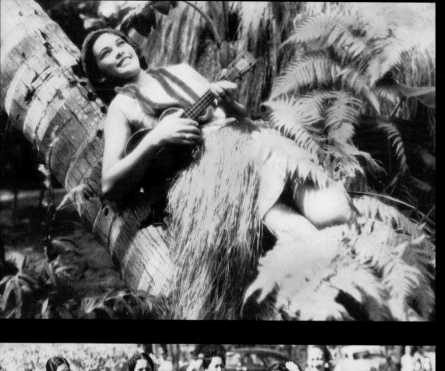

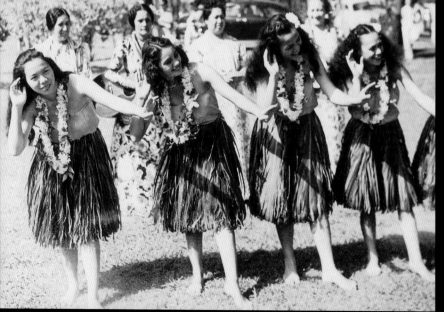

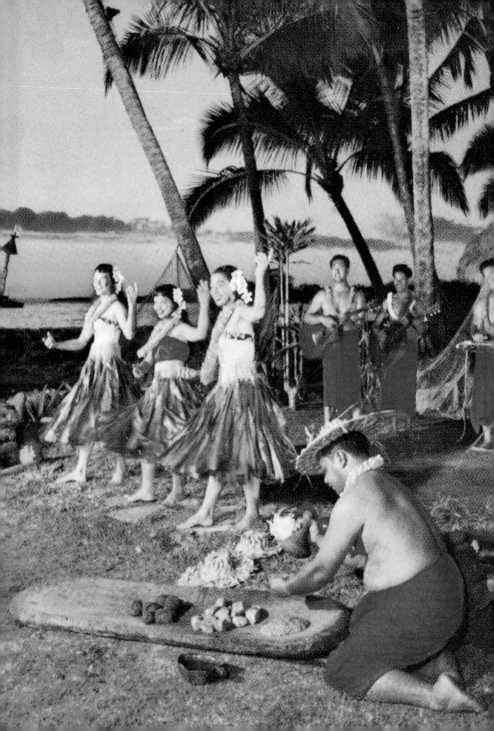

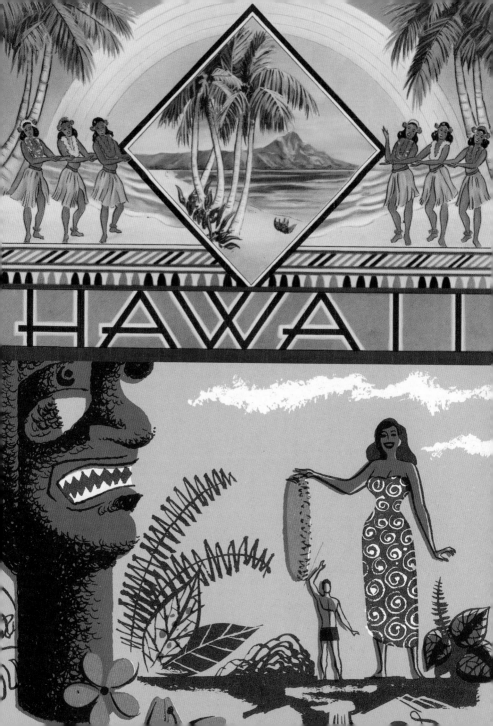

HAWAII

shops and services

Royal Hawaiian
HOTEL

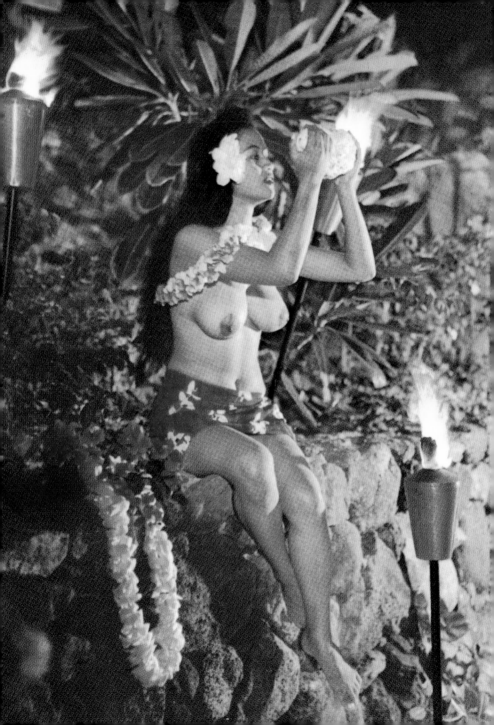

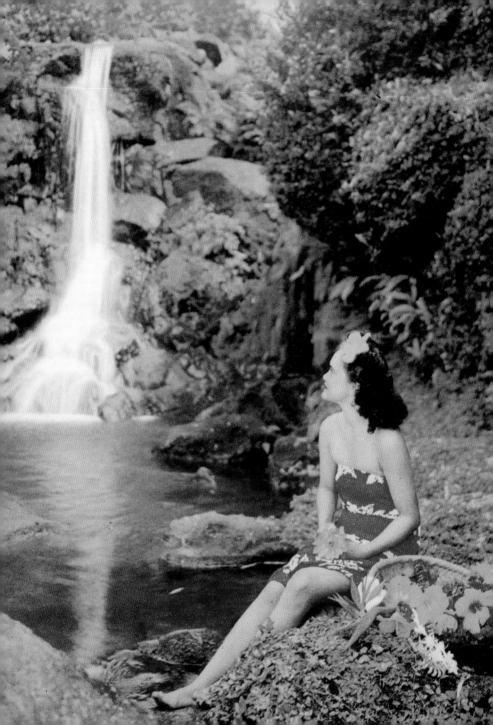

HAWAIIAN PARTY BOOK

HOW TO ENTERTAIN THE HAWAIIAN WAY

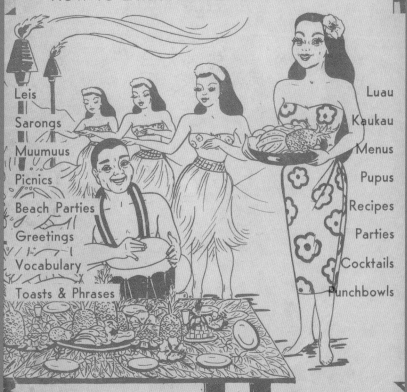

Leis

Sarongs

Muumuus

Picnics

Beach Parties

Greetings

Vocabulary

Toasts & Phrases

Luau

Kaukau

Menus

Pupus

Recipes

Parties

Cocktails

Punchbowls

For KAMAAINA and MALIHINI

PRICE: ONE DOLLAR

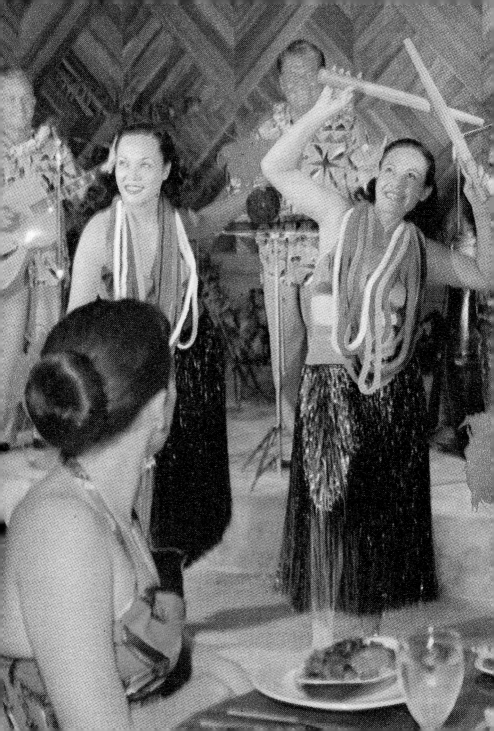

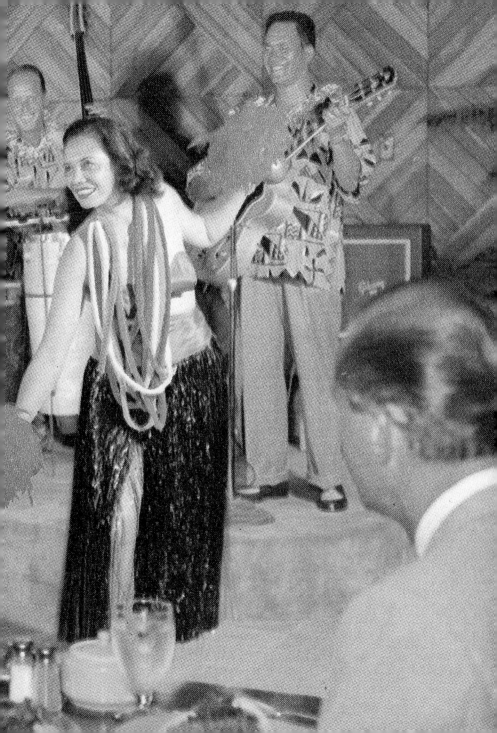

HAWAIIAN FAVORITES

TOPS
MASTERPIECES

HAWAIIAN WAR CHANT

SONG OF THE ISLANDS

LOVELY HULA HANDS

MY LITTLE GRASS SHACK

AKONI LANI AND HIS ISLANDERS

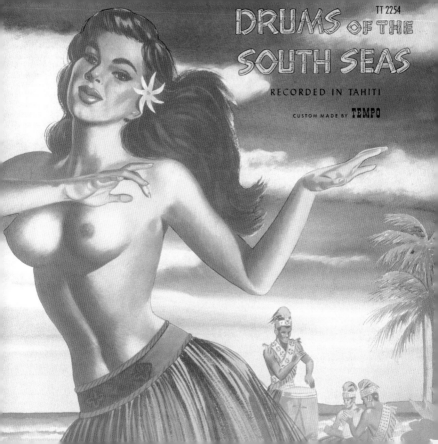

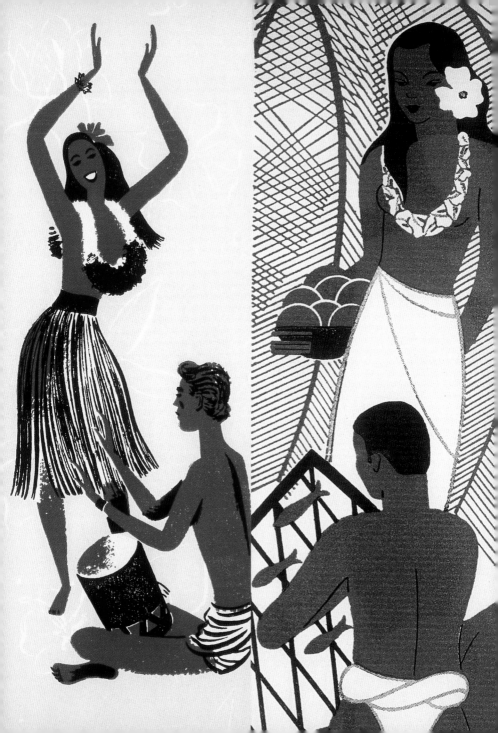

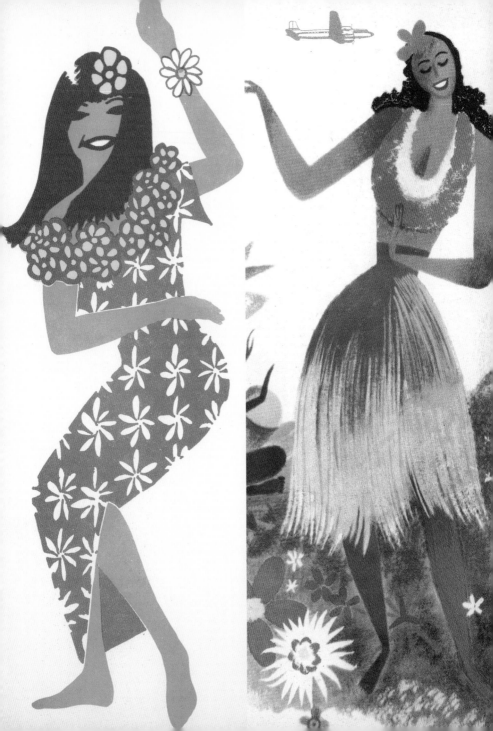

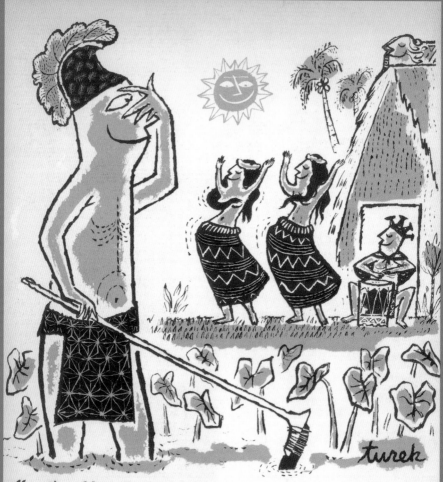

..".actually, the average man in the taro patch knew nothing of naughty dances."

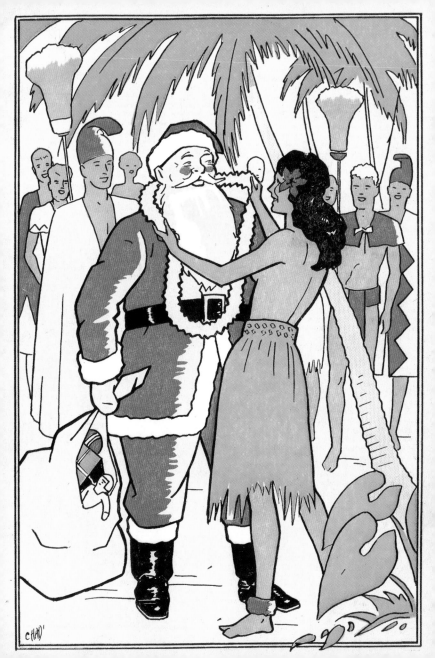

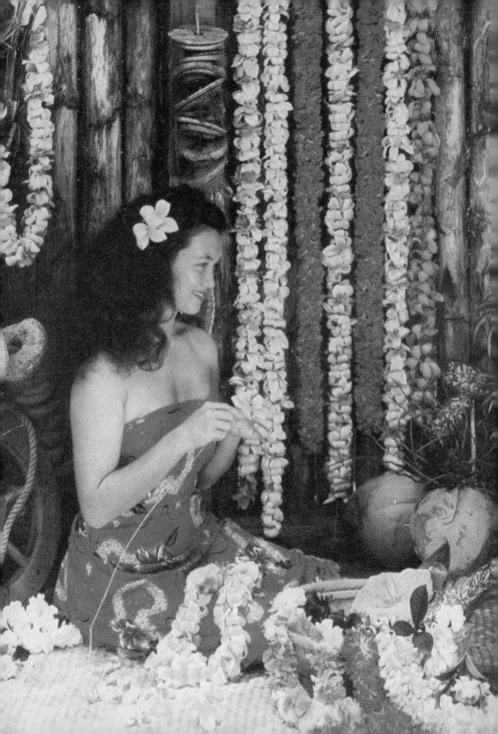

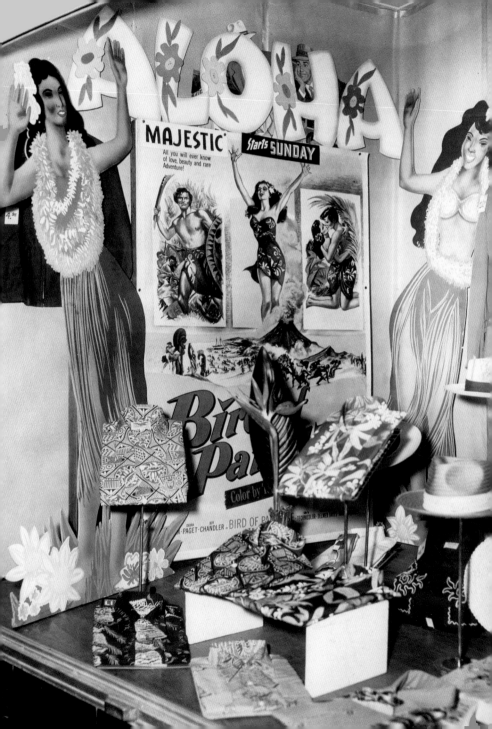

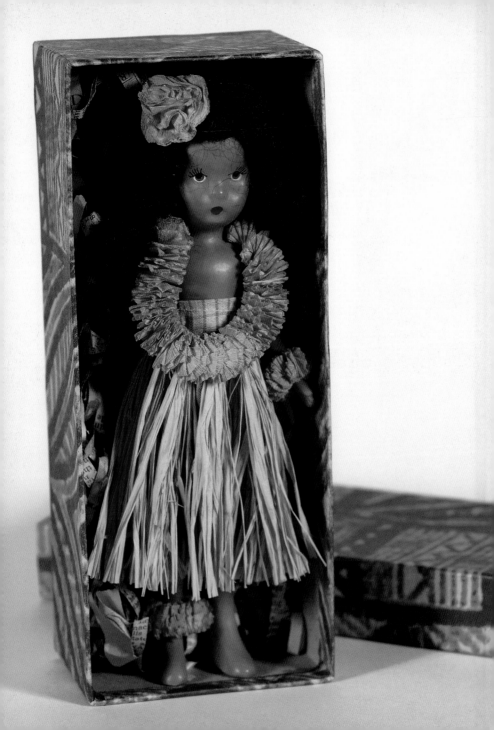

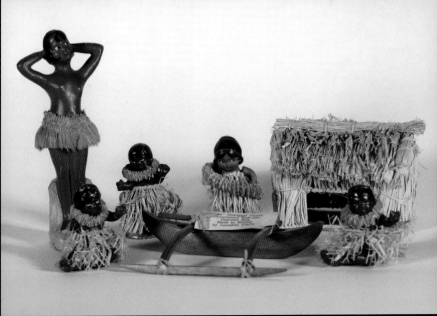

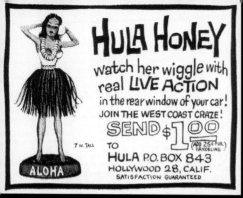

HULA HONEY

watch her wiggle with real **LIVE ACTION** in the rear window of your car!

JOIN THE WEST COAST CRAZE!

SEND $1⁰⁰ (ADD 25¢ FOR HANDLING)

7 IN. TALL

TO **HULA** P.O. BOX 843 HOLLYWOOD 28, CALIF. SATISFACTION GUARANTEED

ALOHA

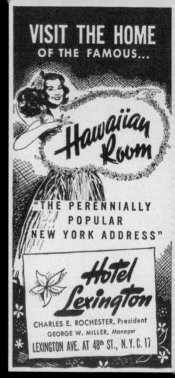

VISIT THE HOME
OF THE FAMOUS...

Hawaiian Room

"THE PERENNIALLY POPULAR NEW YORK ADDRESS"

Hotel Lexington

CHARLES E. ROCHESTER, President
GEORGE W. MILLER, Manager

LEXINGTON AVE. AT 48th ST., N.Y.C. 17

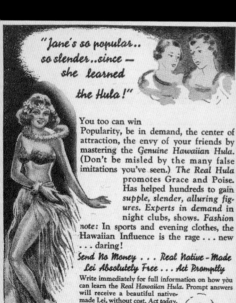

"Jane's so popular.. so slender..since — she learned the Hula!"

You too can win Popularity, be in demand, the center of attraction, the envy of your friends by mastering the *Genuine Hawaiian Hula.* (Don't be misled by the many false imitations you've seen.) *The Real Hula* promotes Grace and Poise. Has helped hundreds to gain *supple, slender, alluring figures. Experts in demand in night clubs, shows. Fashion note:* In sports and evening clothes, the Hawaiian Influence is the rage . . . new . . . daring!

Send No Money . . . Real Native-Made Lei Absolutely Free . . . Act Promptly

Write immediately for full information on how you can learn the *Real Hawaiian Hula.* Prompt answers will receive a beautiful native-made Lei, without cost. Act *today.* Send name and address to:

HAWAIIAN SCHOOL OF HULA DANCING
BOX 3294 HONOLULU
TERRITORY OF HAWAII

UNIQUE FILMS for EXCELLENT QUALITY!

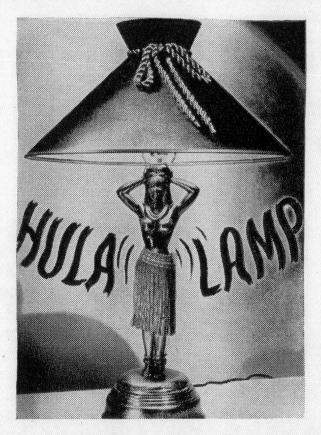

It's animated! The skirt on the handsome bronze figure moves in lifelike "hula" motions. Operated by a small 60 cycle—7 watt motor. Height 22" (figure 15"). 16" rich velveteen shade in Red or Green to match "grass" skirt. **$22.50** postpaid (No C.O.D.'s).

Send for free Catalog of Smart Bar Accessories

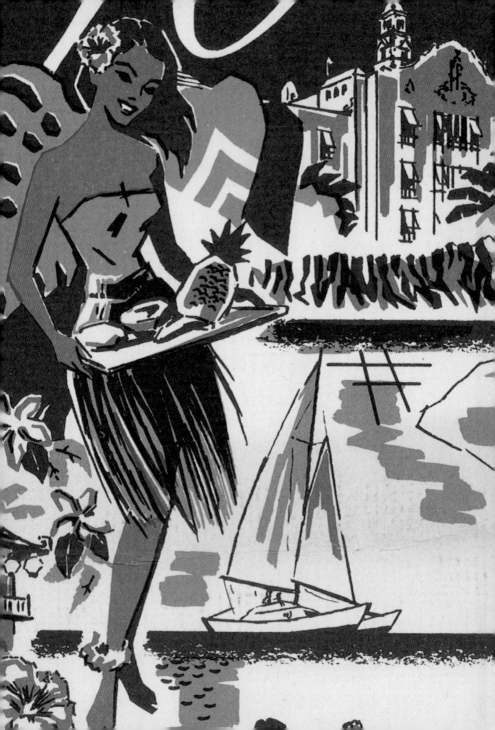

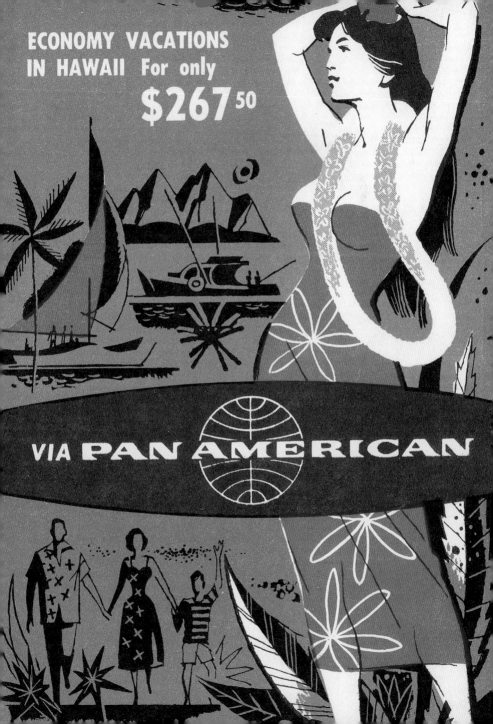

ECONOMY VACATIONS
IN HAWAII For only
$267.50

VIA PAN AMERICAN

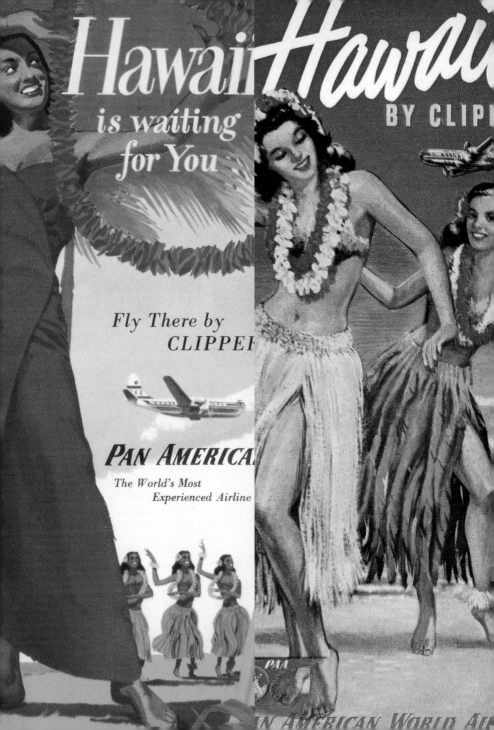

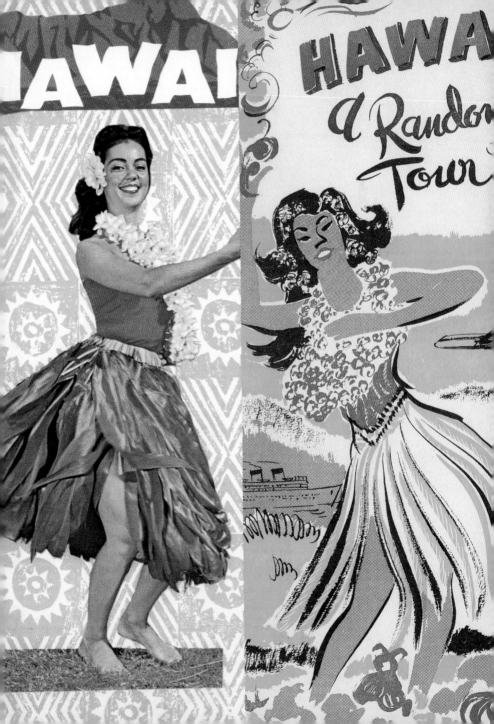

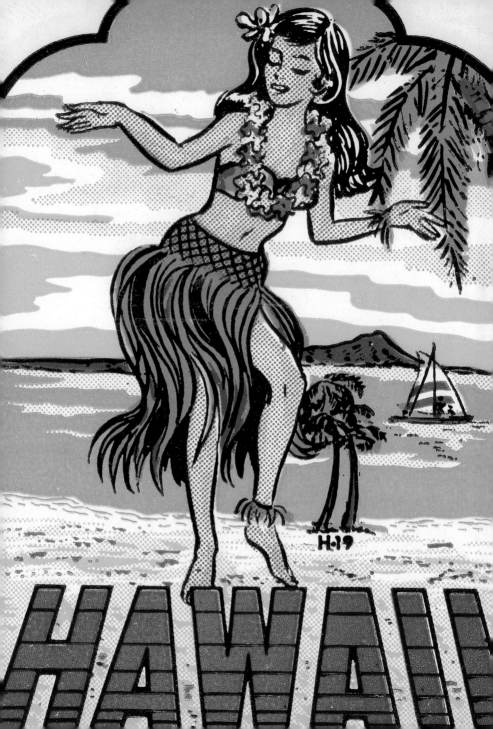

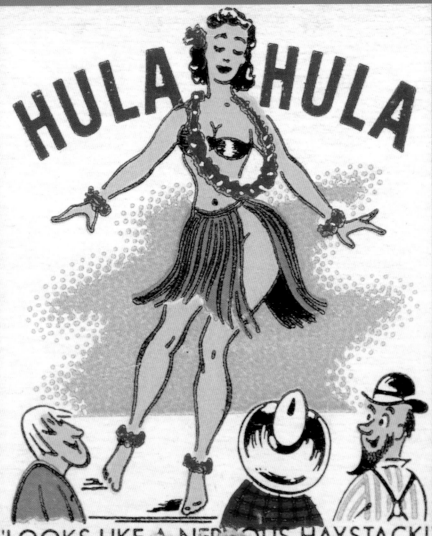

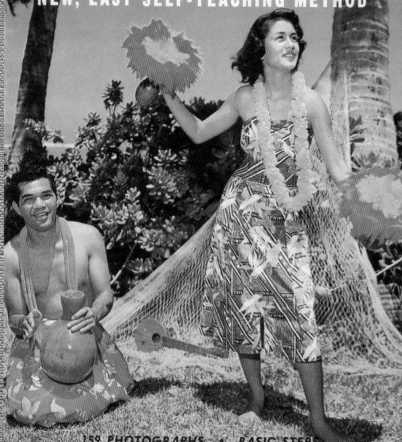

HULA !

NEW, EASY SELF-TEACHING METHOD

159 PHOTOGRAPHS • BASIC STEPS

5 MOST POPULAR HULA SONGS!

The Hukilau Song Keep Your Eyes on the Hands
To You Sweetheart Aloha My Waikiki Girl
Hawaiian Hospitality

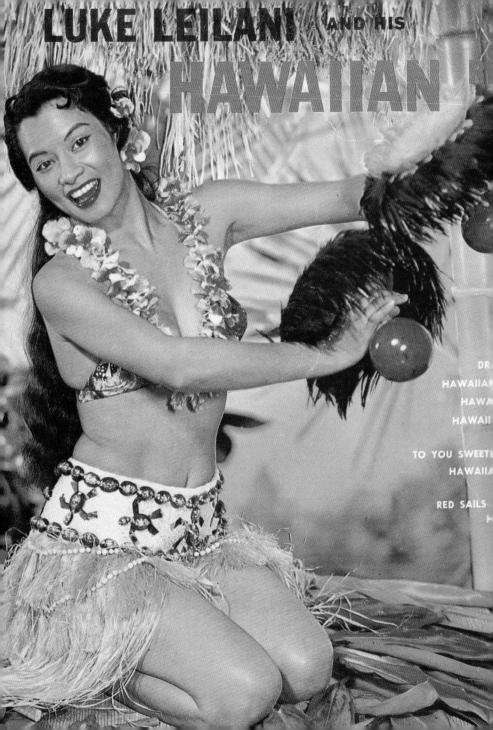

All-American Ads of the 40s
W.R. Wilkerson III, Ed. Jim Heimann / Flexi-cover, 768 pp. / € 29.99 / $ 39.99 / £ 19.99 / ¥ 4.900

All-American Ads of the 50s
Ed. Jim Heimann / Flexi-cover, 928 pp. / € 29.99 / $ 39.99 / £ 19.99 / ¥ 4.900

All-American Ads of the 60s
Steven Heller, Ed. Jim Heimann / Flexi-cover, 960 pp. / € 29.99 / $ 39.99 / £ 19.99 / ¥ 4.900

"The ads do more than advertise products – they provide a record of American everyday life of a bygone era in a way that nothing else can." —*Associated Press*, USA

"Buy them all and add some pleasure to your life."

All-American Ads 40ˢ
Ed. Jim Heimann

All-American Ads 50ˢ
Ed. Jim Heimann

All-American Ads 60ˢ
Ed. Jim Heimann

Angels
Gilles Néret

Architecture Now!
Ed. Philip Jodidio

Art Now
Eds. Burkhard Riemschneider, Uta Grosenick

Atget's Paris
Ed. Hans Christian Adam

Best of Bizarre
Ed. Eric Kroll

Bizarro Postcards
Ed. Jim Heimann

Karl Blossfeldt
Ed. Hans Christian Adam

California, Here I Come
Ed. Jim Heimann

50ˢ Cars
Ed. Jim Heimann

Chairs
Charlotte & Peter Fiell

Classic Rock Covers
Michael Ochs

Description of Egypt
Ed. Gilles Néret

Design of the 20th Century
Charlotte & Peter Fiell

Design for the 21st Century
Charlotte & Peter Fiell

Dessous
Lingerie as Erotic Weapon
Gilles Néret

Devils
Gilles Néret

Digital Beauties
Ed. Julius Wiedemann

Robert Doisneau
Ed. Jean-Claude Gautrand

Eccentric Style
Ed. Angelika Taschen

Encyclopaedia Anatomica
Museo La Specola, Florence

Erotica 17th–18th Century
From Rembrandt to Fragonard
Gilles Néret

Erotica 19th Century
From Courbet to Gauguin
Gilles Néret

Erotica 20th Century, Vol. I
From Rodin to Picasso
Gilles Néret

Erotica 20th Century, Vol. II
From Dalí to Crumb
Gilles Néret

Future Perfect
Ed. Jim Heimann

The Garden at Eichstätt
Basilius Besler

HR Giger
HR Giger

Homo Art
Gilles Néret

Hula
Ed. Jim Heimann

India Bazaar
Samantha Harrison,
Bari Kumar

Indian Style
Ed. Angelika Taschen

Industrial Design
Charlotte & Peter Fiell

Kitchen Kitsch
Ed. Jim Heimann

Krazy Kids' Food
Eds. Steve Roden,
Dan Goodsell

Las Vegas
Ed. Jim Heimann

London Style
Ed. Angelika Taschen

Male Nudes
David Leddick

Man Ray
Ed. Manfred Heiting

Mexicana
Ed. Jim Heimann

Native Americans
Edward S. Curtis
Ed. Hans Christian Adam

New York Style
Ed. Angelika Taschen

Extra/Ordinary Objects, Vol. I
Ed. Colors Magazine

Extra/Ordinary Objects, Vol. II
Ed. Colors Magazine

15th Century Paintings
Rose-Marie & Rainer Hagen

16th Century Paintings
Rose-Marie & Rainer Hagen

Paris-Hollywood
Serge Jacques
Ed. Gilles Néret

Penguin
Frans Lanting

Photo Icons, Vol. I
Hans-Michael Koetzle

Photo Icons, Vol. II
Hans-Michael Koetzle

20th Century Photography
Museum Ludwig Cologne

Pin-Ups
Ed. Burkhard Riemschneider

Giovanni Battista Piranesi
Luigi Ficacci

Provence Style
Ed. Angelika Taschen

Pussy Cats
Gilles Néret

Redouté's Roses
Pierre-Joseph Redouté

Robots and Spaceships
Ed. Teruhisa Kitahara

Seaside Style
Ed. Angelika Taschen

See the World
Ed. Jim Heimann

Eric Stanton
Reunion in Ropes & Other Stories
Ed. Burkhard Riemschneider

Eric Stanton
She Dominates All & Other Stories
Ed. Burkhard Riemschneider

Tattoos
Ed. Henk Schiffmacher

Tuscany Style
Ed. Angelika Taschen

Edward Weston
Ed. Manfred Heiting

Women Artists
in the 20th and 21st Century
Ed. Uta Grosenick

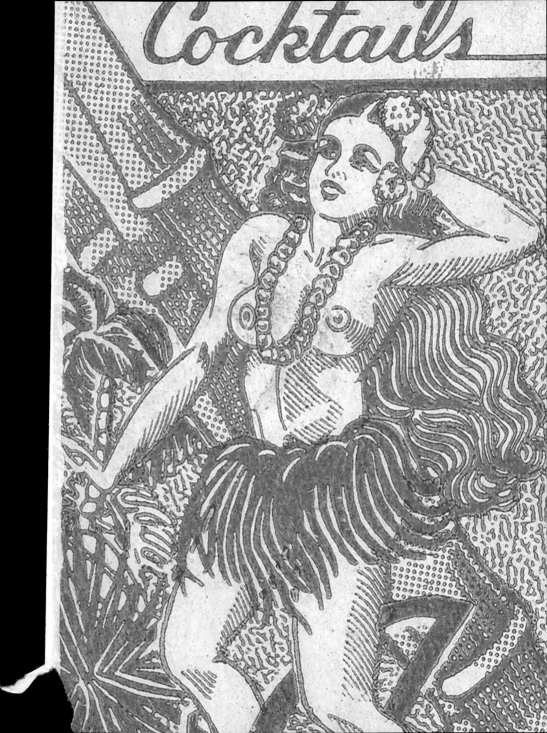

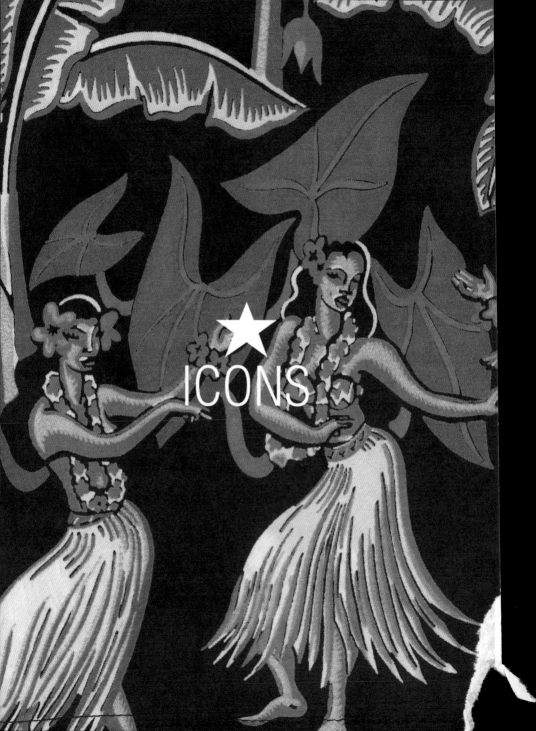